U0132491

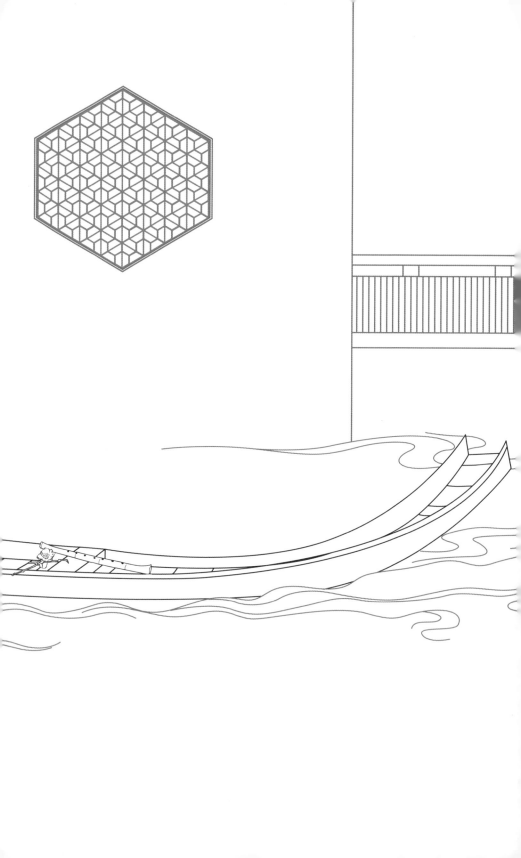

GEM OF *CI* POETRY MUSIC

Reconstruction of Songs by Jiang Kui

edited by Lau Chor Wah

The Commercial Press

Table of Contents

Part 1 **Sharing from Artists**

Part 4 **Musical Reconstruction of the Ten Songs by Jiang Kui**

Foreword one

Luo Di

Jiang Kui, also known as Whitestone the Taoist, was a song lyricist in the Southern Song Dynasty, noted for his distinctive writing style of "reticent resonance", and his superb mastery of composing song lyrics.

There has been a consensus among scholars that the song lyric originated in the Tang Dynasty and the Five Dynasties, flourished in the Northern Song Dynasty and reached its prime in the Southern Song Dynasty. However, as for its singing, there have been disputed views. Most academic books on musicology and renowned scholars, lyricists like Shen Kuo, Zhou Bang Yan, Wu Wen Ying, Zhang Yan in the Song Dynasty and Ling Ting Kan in the Qing Dynasty, had misunderstanding of the tunes. So far as I know, Wang Zhuo and Jiang Kui are the only two exceptions. Jiang Kui also excelled in mastering both elegant and popular tunes, which made his composition unique and unparalleled. After the Southern Song Dynasty was conquered by the Mongols, the study of lyric singing died out. The music scores left by Jiang Kui in *The Songs of Whitestone the Taoist* became the only extant record.

Although highly praised by lyricists in the Qing Dynasty, *The Songs of Whitestone the Taoist* had never been deeply explored until the twentieth century when renowned scholars like Xia Cheng Tao, Yin Fa Lu, Yang Yin Liu and Qiu Qing Sun did their excellent studies. However, as there have been contradictory ideas about the notation recorded in the book, the attempts of singing lyrics composed by Jiang Kui have been rare. Thanks to Koo Siu Sun, Cheung Lai Chun, Sou Si Tai, Lau Chor Wah, Chan Chun Miu and Chung Siu Sun's collective effort, we are able to enjoy the lyric singing. Ever since 2004, they made a record of their singing of Jiang Kui's eight lyrics, and after continuous assiduous study, now they produced a new version with ten lyrics. I appreciate their work and write this preface.

Foreword two

Joseph Lam

Congratulations to the scholars and performers of this historically and musically significant CD publication. Led by Dr. Koo Siu Sun and Dr. Lau Chor Wah, they have produced a recording of their exquisite and informed performance of Jiang Kui's (1155-1221) *ci* (詞) poems, seminal compositions for understanding Southern Song dynasty (1125-1279) literature and music. Since the 17th century, Chinese readers have enjoyed the *ci* poems as literary masterpieces, and since the 1950s, a number of musicologists have attempted to reconstruct the *ci* poems, which Jiang Kui and his fellow musicians sang with instrumental accompaniment.

Reconstructions of the compositions as performable music are daunting tasks, and few have produced musically satisfactory results. This is because that the authentic and preserved notation of the compositions is sketchy, and its rhythmic indication is particularly illusive. Second, Chinese words in the lyrics of the compositions cannot be enunciated with 21st century Chinese Mandarin or dialects, a living language, Chinese pronunciation has evolved through time and space. And third, authentic performance practices of the compositions are unclear, and

contemporary singing methods, and in particular those modern and westernized singing styles which project bright and resonant vocal timbres, create anachronistic dissonances.

Addressing these problems, the scholars and performers sing the *ci* poems with *Kunqu* (崑曲) performance practices and enunciate their lyrics with a system of re-constructed Song dynasty pronunciation. From the recording as one can hear, the result is musical expressive and exquisite, the performers are all master musicians of *Kunqu* singing and *qin* (琴) (Chinese seven-string zither) music playing. Factually and modestly, the scholars and performers declare that they are not singing the *ci* poems as Jiang Kui did; they only aspire to present the compositions in ways that are as close to Song dynasty performances as one can historically imagine and musically reconstruct in the 21st century. As one can hear from their recorded performance, the scholars and performers have admirably and effectively achieved their goal at the highest traditional standard. They perform historical music creatively and interpretively while projecting its preserved artistic and expressive essence authentically and factually.

It is for this intellectual and musical achievement of the scholars and performers that the Confucius Institute at the University of Michigan takes pride in co-sponsoring their CD publication. It is my personal honor and pleasure to contribute this preface to celebrate their work.

Editor's note

Lau Chor Wah

In *The Classics of Poetry* (*Shijing* 詩經), one anonymous poet described a lady's yearning for an unattainable gentleman, "He whom I love must be somewhere along this stream. I went up the river to look for him, but the way was difficult and long." Similarly, we experienced a difficult and long journey to reconstruct the melodies composed by Jiang Kui.

"Great Preface"(*Daxu* 大序) to *Shijing* once explicates the nature of composition:

> *In the heart it is intention; sent forth in speech, it is the poem. The affections are moved within and take on form in speech. When speaking them is insufficient, one sighs them. When sighing them is insufficient, one draws them out by singing. When drawing them out by singing is not sufficient, unconsciously the hands dance them, and the feet tap them.*

The passage demonstrates that in ancient China, the poetry and the song, in terms of their origins and forms, are closely intertwined. As the

two fundamental forms of Chinese art, they both convey Chinese people's genuine emotions and feelings.

Poetry has long been viewed as the essence of traditional Chinese culture. From *Shijing*, *Verses of Chu* (*Chuci* 楚辭), *yuefu* poetry (樂府), Tang *shi* poetry (唐詩), Song *ci* poetry (宋詞) to Yuan *qu* poetry (元曲), the classical Chinese poetry underwent a constant and gradual change over thousands of years, but with no exception, all of the abovementioned genres can be turned into songs. Due to the inherent musicality of Chinese language, ancient Chinese people, wherever they lived, whichever dialect they spoke, could sing the poems.

In the twentieth century, Chinese poetry and music both broke away from the tradition. The modern Chinese poets, after bidding farewell to classical rhythm, prefer redan obscure, twisted language, which is incompatible with music. The Chinese music also underwent tremendous transformation as the intellectuals denounced the value of traditional music and uphold the ideal of westernized Chinese music. The result is that, apart from the nearly extinct opera music and folk music, the westernized music dominates the contemporary soundscape of China, Hong Kong and Taiwan.—the so-called Chinese music (*zhongyue* 中樂, *huayue* 華樂, or *minzuyinyue* 民族音樂) we often hear today is in fact modelled on the Western one. It is history's choice that generations of Chinese have got accustomed to the westernized Chinese music through the education system and mass media, and have been ignorant about the

real traditional music.

Some said, "Each era has its own poetry and music." Due to its immateriality, traditional music, both in the past and at present, tends to disappear with time. For instance, *ci* poetry rose to prominence in the Northern Song Dynasty and singing *ci* poems became in vogue. At that time, there was the saying: "At every place where there was a drinking well, there was someone who was able to sing Liu Yong's (a popular *ci* poet) songs." When the Southern Song Dynasty saw further developments of *ci* poetry and its music, the intrusion of Mongols caused a sudden stop. After the fall of the Song Dynasty, writing *ci* poetry flourished again among literati, but the singing method has been lost forever. The only extant treasure of *ci* music is the scores for the melodies of seventeen *ci* poems composed by Jiang Kui, through which generation of scholars attempted to decode the singing method of Song *ci* poetry.

As a group of friends in fond of traditional Chinese culture, we are curious about the singing method of Jiang Kui's songs. There have been a large number of researches on Jiang Kui's literary achievement, while only a few scholars attempted to reconstruct his music. We collected those records, but none of them satisfied us. The modern reconstructions deviated from our understanding and imagination of the musicality of *ci* poetry: some versions are sung in modern mandarin, which failed to represent the pause-sound and the end rhyme, some are transformed into bel canto, some violated the original tempo and rhythm of Jiang Kui's

ci poems, and some, to our astonishment, are accompanied by piano or orchestra. All of those contradicted our impression of Jiang Kui's songs: the style of "reticent resonance", the musical accompaniment of flute, the subject of "secret fragrance" and "dappled shadows". So we ourselves decided to produce a new version.

Many years ago, encouraged by Dr Koo Siu Sun, several Kunqu amateurs attempted to sing Jiang Kui's songs with "Constructed Song Sound", Kunqu singing method, and the accompaniment of flute. At first we only tried to amuse ourselves, but gradually it became a serious task. In 2004, the Department of Chinese at Hong Kong Baptist University(HKBU) published the record of our performance. In 2012, our new team held a performance of Jiang Kui's songs in HKBU again. On top of that, the expert on *ci* poetry, Prof. Zhang Hong Sheng, the researchers on Chinese music, Prof. Yu Siu Wah and Dr Yang Yuan Zheng, the expert of Kunqu, Dr Koo Siu Sun, gave four academic lectures. We were then invited by the University of Michigan to give a performance in the US, and made a second recording after the trip. Now we edit this pamphlet to collect the lectures, the performers' reflections and the content of the performance.

The goal of our project is not to reconstruct the exact way of singing *ci* poetry in Jiang Kui's time, which is an impossible task. Our efforts can be regarded as experiment based on our studies and our understanding. During our exploration, we have received many valuable comments from

Mr Luo Di. By adhering to the principle of "let zi (Chinese character) lead the singing of the sung phrase", our versions, quite different from others, are produced with free tempo, obvious punctuation, breath stop, and clappers. The singer stops for a while between the upper and lower pieces of the ci poem, and the "Reconstructed Song Sound" and Kunqu mouthing are adopted, producing a nostalgic atmosphere. Although Mr Luo Di indicated that till now there has been no satisfying transcription of Jiang Kui's scores, he fully support our bold experiment. We feel grateful to him.

In his *An Introduction to Ci Poetry*, Liu Xi Zai, a Qing Dynasty critic, described Jiang Kui as "a ci poet with a style of everlasting cold fragrance" and as "a celestial being living in the untraceable mountains". Although the melodies composed by Jiang also seems untraceable, the members of our team, including qin players, qu (曲) singers, calligraphers and painters, dedicated themselves to the project over ten years. Thanks to their cultivation of traditional literature and art, the whole journey is so delightful and enjoyable. Accompanied by Jiang Kui's songs for such a long time, sometimes we really feel, to some extent, we have restored the singing style of the ancient literati. Whether or not our efforts are successful, the project itself shows our sincerity of restoring traditional Chinese culture.

By publishing this book, we aim at sharing our exploration with those who have interests, and also sincerely hope to receive reviews, remarks and critiques. We would like to take this opportunity to thank Dr Chan Man

Hung who made the publication possible. Thanks should also go to the Madam Tsar Teh Yun Endowment Fund and the Confucius Institute at the University of Michigan, for their generous financial support.

An introduction on Jiang Kui

Jiang Kui 姜夔 (1155-1221), style name Yao Zhang and alias Whitestone the Daoist (*Baishi daoren* 白石道人), is a renowned *ci* poet, musicologist and calligrapher in the Southern Song Dynasty.

A native of Poyang, Jiang fell into poverty in his early youth after his father's death. Aiming at honor and success, he took the civil service examinations quite a few times, but always failed. He remained an unemployed scholar for a life time, wandering across the areas of Jiangsu, Anhui, Hunan and Zhejiang in south China. He found an abode in Huzhou in his late years, and then passed away in Hangzhou. Jiang Kui was not only skilled in writing poetry, prose, and *ci* poetry, but also very good at calligraphy and music. Among his works, *The Poetry of Whitestone the Daoist, White Stone Daoist's Discourse on Poetry, The Songs of Whitestone the Daoist* have survived.

Jiang Kui has long been regarded as one of the most influential *ci* poets in the Southern Song Dynasty. Jiang achieved such pervasive fame that he and Zhou Bang Yan, his counterpart in the Northern Song Dynasty, were together known as "Zhou and Jiang". Jiang established a

unique style of his own designated as "reticent resonance" (*qingkong* 清空), different from the two dominant styles: "heroic abandon" (*haofang* 豪放) and "delicate restraint" (*wanyue* 婉約). In Jiang's extant corpus of more than 80 *ci* poems, many dealt with his travel experiences and love affairs, and a few expressed his concern and worry for the declining Song dynasty. A large number of these works can be said to belong to the category of "*ci* poems on objects" (*yongwu ci* 詠物詞), and they were highly acclaimed by the literati. Take the reception of his "*Secret Fragrance*"(Anxiang) and "*Dappled Shadows*"(Shuying), a pair of *yongwu ci* on plums, for instance. In *The Sources of the Ci Poetry*, the literary critic, Zhang Yan upheld the two pieces as models of the style of "reticent resonance" (*qingkong*) and "decorous refinement" (*saoya* 騷雅). Carving out a special niche for himself, Jiang Kui also had a tremendous impact on later *ci* poets. In Qing Dynasty, the two leading schools of *ci* poetry both attached a lot of importance to Jiang's works: Zhexi School paid attention to his artistic techniques, while Changzhou School put emphasis on his implicit feeling and emotions. Having received sustained attention from critics and *ci* poets in the past six to seven hundred years, Jiang Kui's *ci* poetry enjoyed secure canonical status throughout Chinese literary history.

Well conversant with music, Jiang Kui was also able to initiate new tunes of *ci* poetry. Compared to the average *ci* poets, he chose words of different tones relatively freely so as to ensure the harmony between the tones of the words and music, and the genuine expression of inner feelings. In his *The Songs of Whitestone the Daoist*, the scores

for the melodies of seventeen *ci* poems that Jiang himself composed were preserved. This is the only extant musical material from the Song Dynasty *ci* poetry, and has become a key text repetitively discussed by the scholarship of Chinese music history.

Part 1

SHARING FROM ARTISTS

Singing *Ci* Poetry Composed by Jiang Kui

Cheung Lai Chun

Chinese literati art forms, including painting, calligraphy, *qin* and singing, all pursue the linear beauty. In calligraphy, lines which varied in strength, length, rhythm and thickness, are combined to form Chinese characters. In singing, the beauty of melody is achieved in similar ways by combining the appropriate mouthing of zi (字), the musical phrases, breath and rhythm.

Zhang Yan in the Song Dynasty has summarized the principle of singing the *ci* poetry in his *The Origin of Ci poetry*. In terms of the mouthing of zi, he stated, "Don't give a level-tone zi an oblique singing tone; pronounce the zi correctly first, and give it a singing tone that can match it. When one zi is matched with many notes, the singer should prolong the singing to achieve good effect". In terms of breathing, he said, "When singing, the singer should breathe in a calm way. When the music pauses, he shouldn't stop his breath. One has to sustain and twirl his breath to perfect the singing". The Kunqu master singer, Yu Su Lu has made comments as following, "Zhang Yan's summary inherited the tradition of the Tang and Song Dynasty music. The Yuan and Ming

Dynasty musicologists like Wei Liang Fu and Liang Bo Long all based their theories of singing on Zhang Yan's principles. During the reign of Emperor Qianlong and Emperor Jiaqing in the Qing Dynasty, Ye Huai Ting, the renowned Suzhou Kunqu singer developed his singing method also under the influence of Zhang Yan." It is obvious to see that the method of singing Kunqu originated from that of singing ci poetry and the Ming and Qing Dynasty musicologists' theory of singing Kunqu followed the tradition of singing ci poetry. There are many other examples. In *Handbook for Qu-singing*, Shen Chong Sui discussed ways of releasing zi from the mouth and ways of concluding the sounds of zi; in *The Tradition of Sung Poetry*, Xu Da Chun, the Qing Dynasty musicologist, expounded the unique ways of releasing zi from the mouth, the four consonant-issuing positions in the oral-cavity, the four vowel-forming mouth-shapes, concluding the zi on its rhyme, concluding the sounds of zi, the handling of rhythm, light and airy or heavy and solid sound effects in singing, slow and quick tempo. Although what they focused on is Qu-singing, it can serve as an excellent reference for ci poetry singing.

As Kunqu singing adheres to the principle of "let the zi lead the singing of the sung phrase" and strict rules of transforming vocal sounds into musical sounds (that is to say, the mouthing of the zi and the handling of sung phrases and breath both depend on the text), its techniques are much more suitable for singing ci poetry compared with those of folksong singing and operatic singing. However, unlike Kunqu music whose melody is prolonged, in ci poetry music, each zi is matched with one note. To sing a zi properly, the method of *fanqie* (反切) should be adopted. To

put it in Shen Chong Sui's words, "There is a parallel between *fanqie* and the method of singing zi in Qu." Other skills discussed by these Qu musicologists are also illuminating: the technique of mouthing the zi is crucial to clearly presenting all the phonetic elements to be sung; the method of concluding the zi helps to grasp it properly and fully; the handling of breath depends on breathing skills like accumulating breath, taking breath, stealing breath and changing breath; the sentiment of the text is expressed through prolonging and ending the zi appropriately.

Jiang Kui's *ci* poems are noted for their decorous refinement and reticent resonance. To make clear the feelings and emotions within the poems through the simple melody, we have to portray every zi, every sentence properly and singing in the "Reconstructed Song Sound" polished by Mr Koo Siu Sun is undoubtedly an excellent choice. For example, due to Mr Koo's efforts, we are able to end the zi with closed mouth in "*Secret Fragrance*" (Anxiang) in a twirling way, and sing the pause-sound zi with clear rhythm. The reconstructed Song sound helps me to sing the poems like handling brushes in calligraphy.

As I am entrusted to sing the *ci* poems composed by Jiang Kui according to the scores Mr Koo Siu Sun has polished, I have to resort to my experiences of singing Kunqu to correct the pronunciation of the zi and the musical phrases with the accompaniment of *qin* and flute. We may fail to grasp the essence of *ci* poetry singing as we are reconstructing it based on our superfluous studies, but our effort itself is enjoyable.

A Tentative Effort in Singing Jiang Kui's *Ci* Poems

Chan Chun Miu

I knew very little about Jiang Kui's music except that I have once heard Ms Cheung Lai Chun's singing. The tranquil atmosphere impressed me when Ms Cheung and other masters were recording their performance. Recently they have decided to make a new record and add some *ci* poems sung by a man singer, so I was invited to participate in this project. With no basic knowledge of the *ci* poetry singing, I turned to Mr Koo Siu Sun for help and began to learning it, both similar to and different from my past experience of learning Kunqu Opera from him.

"Reconstructed Song Sound" and Southern Fujian Dialect

This time, instead of using Mandarin, or Central accent applied to singing Kunqu Opera, Mr Koo Siu Sun chose the "Reconstructed Song Sound", similar to Southern Fujian dialect in terms of pronunciation, my mother tongue and a descendent of the Song Dynasty language. The familiarity made me feel at ease. When practising singing, Mr Koo often consulted me about the pronunciation of a certain characters in Southern Fujian dialect, and revised the "Reconstructed Song Sound" accordingly

to make it sound more melodious and natural.

Someone may question, "Can the reconstructed Song sound represent the real pronunciation of the Song Dynasty language?" Our answer is that what we want to represent is not the real pronunciation of the Song Dynasty language. The overall goal of reconstructing the Song sound with reference of Southern Fujian dialect, which sounds more unsophisticated and various than Mandarin, is to fully portray the beauty of Chinese characters.

Ci poetry and Kunqu Opera

As *ci* poetry and Kunqu Opera both belong to the set-tune music, the singing technique of Kunqu Opera can also be applicable to *ci* poetry. When singing a Chinese character, I should emphasize the consonant by adjusting the breath and the shape of my mouth and putting some strength so that the listener could hear it clearly. When singing the vowel, I have to polish the twist and shift to achieve a soft and easy effect. It is also important to end the character appropriately. In a word, the beginning, the middle and the end of a character should all be sung in a proper way.

Singing *ci* poetry also differs from singing Kunqu Opera. Mr Koo often reminds me not to prolong the beginning, the middle and the end of a character like singing Kunqu Opera. The reason is that, in Kunqu Opera, each character is matched with several notes, while in *ci*

poetry, each character, one note. If I sing the *ci* poems as dilatorily and ornamentally as Kunqu Opera, the listener may get lost in the tune rather than recognize different characters.

Singing the Character, the Tune and the Poem

It is also important to portray the distinctive feature of each *ci* poem. Someone can't tell the difference between Jiang Kui's *ci* poems after hearing the music, partly because Jiang Kui's works share similar contents and tunes, partly because the singer fails to convey the emotions embedded in each poem.

For a Kunqu Opera singer or a *ci* poem singer, it is important to grasp not only the characters and tunes, but also the contents. Although Jiang Kui's *ci* poems are all characterized by the style of reticence and the theme of loneliness, the difference between those dealing with loving affair and those obsessed with the country is obvious. The singer should bear it in mind. Although the tunes are fixed, the tempo, the pace and the treatment of specific characters are up to the singer. It is the singer's privilege.

For example, when singing "the cold moon makes no sound" in "*A Slow Song about Yangzhou*" (Yangzhouman), I pronounce the character meaning "the moon" very briefly and sing the following characters after a short pause. When singing "waves stir at midstream", I prolong the

character meaning "stir" to achieve the effect of waving. I try to make it sound natural rather than artificial, but sometimes fail.

Therefore, it is crucial to express the emotion of each poem. Different singers' techniques of singing vary. However, if the singer is devoted, he can achieve good effect by using simple techniques. When practicing "*A Slow Song about Yangzhou*", I was touched by my singing several times. But it is occasional. It is really difficult to sing the *ci* poems perfectly.

Musical Accompaniments of Ten Lyrics Composed by Jiang Kui

Sou Si Tai

Eight years ago, I used to interpret several pieces of music composed by Jiang Kui with a few companions fond of Chinese traditional music. I used the *qin* as the accompaniment instrument, and the *xiao*(簫) flute was involved later. Now we try to renew our experiences of those bygone days by performing the *qin-xiao* duet again.

Chinese traditional *di* (笛) flute and *xiao* flute both have equidistant finger holes, which can play the music of heptatonic scale widely used in Chinese folk music. However, the semitone of Chinese musical scale is wider than other scales, probably due to the equidistant finger holes. There are also other Chinese musical instruments that use this musical scale, like the *pipa* (琵琶) (four-stringed Chinese lute) and the *bili* (觱栗) (a bamboo pipe with a double reed that originated from Kucha). Kunqu Opera (an opera genre originated in the Ming Dynasty) also adopted this heptatonic scale.

Jiang Kui is fond of the *xiao* flute. When he and his lover, Xiaohong, passed in a boat through the Chuihong Bridge, she crooned his newly-

written lyrics while Jiang Kui played the *xiao* flute; when he met with his friend Yu Shangqing, an excellent singer, Jiang did the same; still, when coming across an experienced *pipa* musician, Jiang consulted him about the technique of playing the *pipa*, and composed a piece of music. Moreover, he requested the grand master Tian Zhengde using the mute *bili* (a version of the *bili* with a reduced resonance box) to play his self-made new tune. Judging from these stories, we concluded that Jiang Kui preferred the heptatonic scale and we adopt it when playing the music of the ten lyrics chosen by Mr Koo Siu Sun.

We used a silk-stringed *qin* as the accompaniment instrument. Because of its low pitch and small volume, we chose a rather low-pitch and small-volume *xiao* flute to match it. In so doing, singers sing in a comfortable way, and the music harmonizes with the singing.

The music composed by Jiang Kui is superb, which features both tenderness and variance. Every single song was planned to be sung in Song sound this time, which has plentiful changes in tones of words and phrases. The stop, link and fluctuation created by the four tones in Chinese pronunciation may just echoes the variations of melody. In addition, clappers and drum's timely working enhanced the rhythms. Every participant feels enjoyable when we rehearse the music. This exploration is, for us, a really gainful journey in music.

Playing *Qin* among the Gems of Song

Chung Siu Sun

It is my great honour to participate in the project of reconstructing songs composed by Jiang Kui as the *qin* (Chinese seven-string zither) player. I am grateful for my dear mentors who kindly guided me through and scholars who helped me to overcome many aesthetical and musical problems of transcribing *ci* poem music to a classical *qin* score. The brief principles of my *qin* music writing are as follows:

Musical transcription of *ci* poetry

Despite ancient hints notated originally by Jiang Kui, there are two major sticking points toward a good transcribed music on *qin:* the adaptation according to the interpretation of the *ci* poems, and, the traditional *qin* principles of technical manipulations. For example, in the wake of "A Slow Song about Yangzhou" (*Yangzhouman*), harmonics and open-strings are adapted for the atmosphere, while mellow pressed-notes are applied for the mournful verses followed. Pair with the singing articulation, different techniques had been introduced to match particular rules, such as 'muk', 'yuet' and 'luk' with *fu* (伏絃) (sudden-mute); 'shang'

and 'nian' with *zhuo* (綽) or *zhu* (注) (sliding notes) for musical reasons.

Ambiguity of Pitch Sense

Basically, there are seven degrees of Jiang Kui's modal scales. The corresponding pitches are placed with the *di* or *xiao*, which is crafted by ancient equidistant-hole method. The 4^{th} degree is slightly higher than the 6^{th} of Andreas Werckmeister's circular temperament; while the 7^{th} degree is slightly lower than the 12th of Werckmeister's. However, in the actual ensemble, some dedicated pitches were naturally altered by the meaning of the word, as well as the emotional nuances, such as 'jun [glamorous]' in "du lang jun shang" and 'zong [an accented conjunctive adverb: moreover] 'in "zong dou kou ci gong" of "*A slow song about Yangzhou*" (Yangzhouman).

In Search of Sonority

In this transcription, there is no excess melodic additive for the subtle and spacious impressions as the context offered in Jiang Kui's *ci* poetry. Some inconspicuous technical detail such as *nao* (猱), *yin* (吟), *jinfu* (進復) and *xuyan* (虛罨), the quiet codetta of "*A Slow Song about Yangzhou*", or, even the uncommon chords (Perfect 4^{th}) appearing at the end in "*Spring Blossom in Lone Hill*" (Gexi meiling) and "*A Song in the Jue Mode*" (Jueshao) may give some memorable sonorities and feelings, leaving all of this unsettled.

Sound Engineer's words

Christopher Keyes

The overall goal of the recording was to achieve a sound as close as possible to how we believe the repertoire would have originally been heard. This includes the approximate dimensions of the space and sonic characteristics of a court hall. In such a space the timbre of each instrument should be heard clearly, but the ensemble should blend together naturally. For this we used a combination of close and ambient microphone techniques, and both digital and analog tube (valve) equipment.The *qin* was especially challenging to record due to its many timbres. To capture them we used three microphones: one over the plucking of the right hand, another over the scraping and effects of the left hand, and another between the bottom of the instrument and its stand, to capture the instrument's warmth and bass frequencies.

Equipment list:5 x Sennheiser MKH800, 2 x DPA 4011s, Neumann U87, and Manley Reference microphones. These were powered by Earthworks 1024 and Avalon 737SP microphone preamps, feeding Apogee converters with Millenia NSEQ~2 Tube equalizer.

Part 2

TRACING ORIGINS (SUMMARY)

Revisiting Jiang Bai Shi

Yu Siu Wah

The Sung poet musician Jiang Kwai (Bai Shi) has long been hailed as an artist who lived a life devoid of secular concerns. Using an alleged autobiography of Jiang, the paper revisits Jiang the ordinary man whose aspiration to recognition almost comes to the point of self-promotion. By citing all the big names in the literati and government circle of his time who he claimed to have admired his multifarious talents, Jiang projects an image of extraordinary abilities in various genres of arts, including poetry, calligraphy, literature and music etc. In his autobiography, however, the narrative of the death of Zhang Ping Fu, the patron who supported Jiang's living and proposed to buy him an official post from the government, is in congruence with Jiang's literary style.

The paper summarizes the significance of Jiang's music notation in Chinese music history. Using transcriptions of Jiang's notation by various scholars, issues of temperament and performance practice with respect to scholars' decisions in their transcriptions are also addressed.

Reference

- Lam, Joseph S.C, "Chinese Music Historiography: From Yang Yinliu's A Draft History of Ancient Chinese Music to Confucian Classics", *ACMR Reports,* Vol. 8 no. 2, 1995, pp1-46.

- Lam, Joseph S.C, "Writing Music Biographies of Historical East Asian Musicians: The Case of Jiang Kui", *The World of Music,* 43 (1) 2001, pp70-95.

- Liang, David, "The Tz'u Music of Chiang K'uei: Its Style and Compositional Strategy", *Rendition,* Nos. 11&12, Special Issue on Tz'u (Hong Kong: The Chinese University of Hong Kong, 1979), pp211-246.

- Pian, Rulan Chao , *Song Dynasty Musical Sources and Their Interpretation* (Cambridge, Mass: Harvard University Press, 1967; rep. Hong Kong: The Chinese University Press, 2003).

- Tse, Chun Yan, "From Chromaticism to Pentatonism: A Convergence of Ideology and Practice in Qin Music of the Ming and Qing Dynasties", PhD diss., CUHK, 2009.

The Interpretation and Reception of *"Secret Fragrance"* and *"Dappled Shadows"* Through History

Zhang Hong Sheng

In this article, my discussion is mainly centered on the interpretation and reception of the two most quoted and admired song lyrics by Jiang Kui, *"Secret Fragrance"* and *"Dappled Shadows"*, which have been universally acknowledged as masterpieces in the Chinese lyrical tradition.

Instead of analyzing Jiang Kui's composition of the pair of song lyrics on plum blossoms in detail, I intend to illustrate how they began their journeys in the history of literary reception. My introduction starts with the influential comment made by Zhang Yan, Jiang's contemporary critic who explored the theory of the song lyric—Zhang praised the two pieces as "unparalleled works" by placing emphasis on their stylistic features of "decorous refinement" and "reticent resonance". However, during the Yuan and Ming Dynasty, Jiang's writings were so neglected that none of his works were selected for the most popular anthology. It is not until the Qing Dynasty that *"Secret Fragrance"* and *"Dappled Shadows"* aroused great

interest again among the literati because the two most influential song lyric schools, Zhexi and Changzhou, both regarded them as masterpieces. Interestingly, they offered diverse approaches of interpretation, implying the richness and ambiguity embedded implicitly in Jiang's writings.

Let us first explore how the Zhexi School appraised the two lyrics. It should be noted that the Southern Song lyrical tradition, especially the writing of "song lyrics on objects" (*yongwu ci*) represented by Jiang Kui and Zhang Yan, was upheld as a model by the Zhexi School. Its leading lyricist Zhu Yi Zun stated, "When people talk about the song lyric, they always refer to the Northern Song Dynasty, yet the genre did not reach its technical peak until the Southern Song, and it was only by the end of the Song that it displayed all its variety, Jiang Yao Zhang (Jiang Kui) was the most outstanding one among them". It might be a pity that Zhu made no comments on the pair of song lyrics when incorporating them into the anthology he edited, but it was remedied by his disciple, Xu Ang Xiao, who claimed that the techniques utilized by Jiang Kui, like inversion, allusions and foregrounding, should be cherished by later lyricists as golden rules.

Unlike the Zhexi lyricists who canonized Jiang's lyrics in terms of artistic techniques, the Changzhou School read them as allegory. Take Zhang Hui Yan, its founder for example. In the anthology of song lyrics he edited, he interpreted *"Secret Fragrance"* as Jiang's plea for his patron and friend Fan Cheng Da to quit hermitage and revitalize the declining

dynasty, and read "*Dappled Shadows*" as a lament for the capture of the ill-fated last two emperors of the Northern Song Dynasty by the Jurchens. Under Zhang's influence, many later lyricists of the Changzhou School offered similar interpretations. Although this approach is not applicable in some cases—for instance, it is impossible for Jiang Kui to urge his friend to work for the emperor as Fan Cheng Da was much older in age—the allegorical reading provided a new perspective on literary analysis for later lyricists and critics.

What caused the different modes of interpretation? The early Qing Dynasty saw the revival of song lyrics on objects, which has something to do with Zhu Yi Zun's effort. It is thus reasonable for the Zhexi School to promote the writing of song lyrics on objects by discussing, arguing for, and lauding the art with exquisite refinement exemplified by their literary canons, "*Secret Fragrance*" and "*Dappled Shadows*". But why did the Changzhou School, established by those unsatisfied with the dominance of the Zhexi School in the literary field, also praise the two pieces highly? Faced with the prevalent literary discourse advocated by the Zhexi School, it was more difficult for the rival to negate its validity than to offer a diverse interpretation of the existent canons. In doing the latter, the Changzhou School succeeded in developing and promoting an allegorical reading of Jiang Kui, which was in consonance with their era when the Qing Dynasty began to experience a similar decline.

Reuniting Music and Poetry:
Republication of the *Songs of Whitestone the Daoist* in the Qing Dynasty [1]

Yang Yuan Zheng

The study of the *Songs of Whitestone the Daoist* has long been a topic of central interest to the scholarship of Chinese music history. The text was first published as early as 1202, but languished in oblivion until 1743, when Lu Zhonghui, a salt merchant, republished the book in Yangzhou (hereafter the Lu edition). Since the publication of this edition, many scholars, both Chinese and Western, have written their own studies of it. Lu's edition, thus, not only marked a turning point in the status of the *Songs of Whitestone*, but also exerted an important influence on research into *ci* poetry in the Qing dynasty.

In spite of its significance, little was known regarding details as to how the Lu edition was produced, which may account for it being subsequently underestimated. In 1862, a noted scholar Zhang Wen Hu, whilst praising a later edition published by Zhang Yi Shu in 1749, condemned the Lu

1 Research for this article was supported by the Seed Funding Programme for Basic Research (201203159004) at The University of Hong Kong.

edition as a book made by "an opulent merchant, riddled with arbitrary changes and bereft of the original intention of the author". His comments have been echoed by a majority of late Qing lyricists, who have tended to view businessmen with contempt, and, even today, this remains a common viewpoint in the fields of Chinese musicology and literature, leaving a legacy that still influences the modern scholarly study of *ci* poetry.

Is Lu's edition of the *Songs of Whitestone* merely the product of a philistine salt merchant pretending to be a cultivated man? If so, why did it still cause such a sensation after its publication? To answer these questions, my paper will first discuss the beauty of *ci* poetry as song, then probe into the details of how the *Songs of Whitestone the Daoist* — the only extant collection of *ci* poems that preserves musical notations — was republished in Yangzhou, in the light of a newly-discovered manuscript copy of the text.

Ci poetry was originally a song form. So-called *ci* poems, which we nowadays appreciate purely as literature, were originally written in the Song dynasty as lyrics (*ci* means 'lyrics'). The tunes to which the lyrics were written were known as *cipai* (詞牌), and each *cipai* has a more-or-less fixed melody and rhythm. Therefore, if a lyricist wrote lyrics for pre-existing tunes, he simply had to write down the name of the *cipai*, and it was not necessary for him to notate the music, since most of the tunes were widely circulated by oral transmission at that time. In the late Song period, however, *ci* poetry gradually developed into so refined a form

that its status as a popular art was replaced by other vocal genres, such as *nanxi* (南戲) and *zaju* (雜劇). Soon the tunes were lost and only the texts remained. Removed from its music, *ci* poetry turned into a purely literary genre, and *cipai* were relegated to mere prosodic forms.

Without the music, the talk of musicality in *ci* poetry became an empty discourse. Therefore, when *ci* poetry flourished again in the early Qing dynasty, lyricists who wished to recover its musicality, such as Zhu Yi Zun, Li E and Lou Jing Si, lamented that relatively few *ci* with accompanying musical notation had been handed down to them. It was precisely at this juncture that a hitherto lost *ci* poetry collection that includes the requisite musical notation—the *Songs of Whitestone the Daoist* — reappeared. The *ci* poems in this compilation were either composed or collected by Jiang Bai Shi —a Song-dynasty lyricist. At first it was Lou Jing Si who discovered an early manuscript of the collection copied by Tao Zong Yi (hereafter the Tao manuscript), but it was only copied by and disseminated amongst a small group of literati in Beijing. It was not until Lu republished the collection in Yangzhou based on Tao's manuscript that the beautiful melodies of *ci* poetry became once again widely known to the literati. Since then, ensuing editions (including Zhang Yi Shu's edition) were produced.

During my collation of the *Songs of Whitestone*, I have discovered that its republication in Yangzhou was not accomplished by Lu Zhong Hui alone, rather, it was a product of the collective effort and meticulous

planning of the Zhexi school of *ci* poetry and the Hanjiang Poetry Club in Yangzhou, led by Li E and the Ma Brothers respectively. In a newly-discovered manuscript copy of the *Songs of Whitestone the Daoist* — the Wuxiang copy — phrases such as 'Fan Xie said', 'Yu Jing said' and 'Mei Pan said' appear frequently in the collators' notes written in the top margins. 'Fan Xie', 'Yu Jing' and 'Mei Pan' are courtesy names of Li E, Min Hua, and Wang Zao respectively, all members of the Hanjiang Poetry Club, to which Lu Zhong Hui also belonged. All this suggests that the Tao manuscript was scrupulously collated and proofread by the Hanjiang Poetry Club after it had been brought to Yangzhou from Beijing.

A further association can be made with a hand scroll preserved in the Cleveland Museum of Art that depicts a 1743 gathering held by club members, which could be interpreted as equivalent to a commemorative photo taken at the time when they were preparing their edition of the *Songs of Whitestone*. The participants can be divided into three groups— former government officials (e.g. Hu Qi Heng, Quan Zu Wang, and Cheng Meng Xing), lyricists of the Zhexi school (e.g. Li E, Min Hua, and Wang Zao), and their salt-merchant sponsors (e.g. Lu Zhong Hui and the Ma Brothers). It is likely that it was Li E who led the production of the Lu edition. The reason why Lu was entrusted with the printing of this collectively-edited collection of Jiang's *ci* poetry may be because that Lu Zhong Hui owned a private press noted for its exquisite craftsmanship. From the collators' notes found in the Wuxiang copy, we can reasonably conclude that the Lu edition was meticulously and exquisitely crafted,

and that Zhang Wen Hu's disparagement of it as being produced by a philistine merchant is simply untenable. With the discovery of the Wuxiang copy—the closest redaction to the Tao manuscript—the study of music in *ci* poetry has now been led into a whole new realm.

Reference

- Ho, Wai-kam, "The Literary Gathering at a Yangzhou Garden," in Wai-kam Ho ed., et al., *Eight Dynasties of Chinese Painting* (Cleveland: Cleveland Museum of Art, 1980), pp 372-376.

- Lam, Joseph S. C., "Writing Music Biographies of Historical East Asian Musicians: The Case of Jiang Kui," *The World of Music* 43/1 (2001), pp 69-95.

- Pian, Rulan Chao, *Sonq Dynasty Musical Sources & Their Interpretation* (Cambridge, MA: Harvard University Press, 1967).

- Picken, Laurence, "Secular Chinese Songs of the Twelfth-Century," *Studia Musicologica Academiae Scientiarum Hungaricae* 8 (1966), pp 125-172.

- Yang, Yuanzheng, "*Jindou*: A Musical Form Found in Southern Song Lyric Songs," *T'oung Pao* 101/1-3 (2015), pp 98-129.

- Yang, Yuanzheng, "Reformulating Jiang Kui's Lyric Oeuvre: The Canonization of Southern Song Dynasty Song Lyric (*ci*) in the Qing Dynasty," *Journal of the American Oriental Society* 135/4 (2015), pp 709-732.

Singing *Ci* Poetry with Song Dynasty Diction

Koo Siu Sun

Ci is a genre of Chinese poetry and vocal music blossomed during Sui and Tang Dynasties (581-907) and fully developed in North and South Song (960-1279). *Ci* works are literary as they are musical: their poetic texts are written to match the rhyme schemes, patterns of linguistic tones, musical modes, phrasing, number of lines, and other literary-musical features of preexistent *cipai* (tunes or tune form). *Cipais* represent different tunes or melodies of various sources, including traditional Han language songs and sung poems. But most of the tunes are adapted from the music of the ancient minority nations living at the north-west border of the Central Plain.

As literary texts, *ci* lyrics have been comprehensively and continuously preserved in their authors' publications and manuscripts, most of which are readily available through Chinese history. *Ci* music has been less well preserved. The earliest extant and decipherable music notation of *ci* works is Jiang Kui's *Baishi daoren gequji* 白石道人歌曲集 (the Whitestone Daoist's songbook, ca. 1221), which preserves the poet-composer's music for 17 *ci* lyrics and 1 *qin* song. Written side by side the lyrics, the *suzipu*

俗字譜 (popular notation) of Jiang's literary-musical compositions shows only their melodies; their melodic phrasing, rhythms, and other performance details are poetically implied by the literary and linguistic features of their lyrics.

Thus, when "deciphers" the *banshi* (板式) (rhythm and tempo attributes for individual tones/words, phrases, and the overall shape of the composition), and "realizes" the tonal and rhyme attributes of the words in *ci* lyrics, and one can once again "perform" *ci* songs. A number of historical and contemporary writings have informed on *ci* rhythmic structures and their performance practices. Zhang Yan (1248-1320) has, for instance, reported that *banshi* can either be the *guanpai* 官拍(obligated beats mode) or the *yanpai* 艷拍(or decorated beats mode 花拍). Zhang has also stated that short (*ling* 令), medium (*jin* 近) and long (*man* 慢) *ci* songs have, respectively, four, six and eight *ban* 板(clapper beating or rhythmic cycles articulated by the beating of clappers). Yang Yin Liu (1899-1984), and the first scholar who transformed Jiang Kui's ci music from Song popular notations into modern western notations, has argued that the *banshi* of *ci* songs can be realized from the semantic and syntactic features of the lyrics, and from the natural lengths of the literary phrases, each of which is affected by how long singers can sing without changing their breaths.

To realize tonal and rhyme attributes of individual words in *ci* texts, one has to accept that historical and theoretical prescriptions cannot

accurately and comprehensively reveal how individual words were actually enunciated during contemporary performances of *ci* songs. Not all performers would enunciate in the *guanhua* 官話 (Mandarin or official dialect) which the treatises describe. And even if they did, they sang with their regional accents. This is to say that there are more than one authentic ways to pronounce words of *ci* lyrics in Song China. Thus, one can argue that the most logical solution for reconstructing Song diction for 21st century performance of *ci* songs is the enunciation that not only matches a form of historical pronunciation but also coordinates well with the rhymes of the poetic lyrics being sung. Such a historically based and musically practical solution can be realized by enunciating *ci* words according to the reconstructed Song sounds of Han characters (*nisongyin* 擬宋音) prepared by Wang Li (1900~1986), a giant of Chinese linguistics.

summarized by Joseph Lam

宋韻遺珍

白石道人歌曲重構

GEM OF *CI* POETRY MUSIC

Reconstruction of Songs by Jiang Kui

錄音説明

製作統籌：劉楚華

演唱：張麗真 陳春苗

古琴：鍾兆燊

洞簫：蘇思棣

鼓板：張麗真 陳春苗

錄音：祈道緯

Production note

Production Supervisor: Lau Chor Wah

Artists: Cheung Lai Chun, Chan Chun Miu

Qin: Chung Siu Sun

Flute(Xiao): Sou Si Tai

Drum and Clappers: Cheung Lai Chun, Chan Chun Miu

Sound Record: Christopher Keyes

【曲目十】

角招

為春瘦，何堪更、繞西湖盡是垂柳。

自看煙外岫，記得與君，湖上攜手。

君歸未久，早亂落香紅千畝。

一葉凌波縹緲，過三十六離宮，遣遊人回首。

猶有，畫船障袖，青樓倚扇，相映人爭秀。

翠翹光欲溜，愛着宮黃，而今時候。

傷春似舊。

蕩一點、春心如酒。

寫入吳絲自奏，問誰識、曲中心，花前友。

Jueshao, "*A song in the jue mode*"

Spring has worn me thin, And how can I bear to see drooping willows all around the West Lake?

Alone I watch the peaks beyond the mist, I remember being with you, Hand in hand on the lake.

In the brief time since you left, A thousand mu of fragrant red have scattered and fallen.

A leaf-like boat crosses the waves in the mist, Passing Thirty-Six Imperial Lodges, That makes the traveler turn his head.

There still remain Those on painted boats who hide behind their sleeves And those on green mansions who rest their fans against their faces — They shine and outshine each-other's charms.

Their kingfisher-tail hairpins gleam; This is the time
When women love to paint their brows with "palace yellow".

I feel sad at spring as in the past,

My small spring-heart stirs me like a glass of wine.

Writing for the strings of a Wu zither, I play to myself,
And ask who knows the heart of the tune and the friend who was with me in front of the blossoms.

英語歌詞參考自林順夫翻譯
Lyrics translation by Lin Shuen-fu

【曲目九】

暗香

舊時月色，算幾番照我，梅邊吹笛。

喚起玉人，不管清寒與攀摘。

何遜而今漸老，都忘卻春風詞筆。

但怪得竹外疏花，香冷入瑤席。

江國，正寂寂。

歎寄與路遙，夜雪初積。

翠尊易泣，紅萼無言耿相憶。

長記曾攜手處，千樹壓西湖寒碧。

又片片吹盡也，幾時見得。

Anxiang, "*Secret fragrance*"

The moonlight of the old days,
How many times, has shone upon me
Playing the flute by the plum trees?

I called my lady,
Ignoring the chill, to pick the blossoms with me.

Ho Hsün is now ageing,
His pen, once spring wind, is wholly forgotten.

He's only bemused by the few flowers past the bamboos,
Whose cold fragrance enters the banquet hall.

The River Country Is just now lonely and still.

I sigh that the road is too long to send a blossom,
And the evening snow begins to pile up.

Tears freely drop in front of the green wine pot;
The red-calyxes are speechless, disturbed by mutual thoughts.

Long shall I remember the places where we held hands:
A thousand trees press against the West Lake's cold green.

Petal by petal, all blown away, When shall I see them again?

【曲目八】

疏影

苔枝綴玉，有翠禽小小，枝上同宿。

客裏相逢，籬角黃昏，無言自倚修竹。

昭君不慣胡沙遠，但暗憶、江南江北。

想佩環、月夜歸來，化作此花幽獨。

猶記深宮舊事，那人正睡裏，飛近蛾綠。

莫似春風，不管盈盈，早與安排金屋。

還教一片隨波去，又卻怨，玉龍哀曲。

等恁時、重覓幽香，已入小窗橫幅。

Shuying, "*Dappled shadows*"

Mossy branches decked with jade;
Tiny, tiny bluebirds Roost on them together.

When wandering we meet —
By the corner of the fence in the dusk
Without a word she leans on slender bamboos.

Unaccustomed to the remote barbarian sands,
Chao-chün secretly longed for the Yangtze's climes.

Surely it is her jade waistband
That returns on moonlit nights,
Transformed into this blossom, so solitary.

The old palace tale still comes to mind:
When that beauty was asleep,
One blossom fluttered to her black moth-eyebrows.

Don't be like the spring wind, Careless of beauty,
But early prepare a gold chamber for it.

If one lets all the petals drift with the current,
He shall resent hearing the sad tune for the Jade Dragon.

If one waits till then to find the subtle fragrance,
It will have entered the horizontal scroll over the small window.

【曲目七】

徵招

潮回卻過西陵浦，扁舟僅容居士。

去得幾何時，黍離離如此。

客途今倦矣。

漫贏得一襟詩思。

記憶江南，落帆沙際，此行還是。

迤邐剡中山，重相見、依依故人情味。

似怨不來遊，擁愁鬟十二。

一丘聊復爾，也孤負幼輿高志。

水溁晚，漠漠搖煙，奈未成歸計。

Zhishao, "*A song in the zhi mode*"

As the tide rises I cross the Hsi-ling waters,
The flat boat can hardly hold an unemployed scholar.

How long have I been away
That the millet has spread like this?

I now have tired of the wanderer's road

All I have gained is a heart full of ideas for poetry.

I remember the South,
When let my sail drop to the sand — Again this time it is so.

Those winding mountains in Yen
I meet again and feel the love of old friends.

They seem to complain that I'm not on a journey,
And hold up their twelve sad topknots.

To visit again just one of these mountains
Is unworthy of Yu-yü's high ambitions.

At dusk the water plants endlessly
Sway in the mist,
But I cannot go home yet.

【曲目六】

杏花天影

綠絲低拂鴛鴦浦，
想桃葉當時喚渡。

又將愁眼與春風，待去，
倚蘭橈更少駐。

金陵路、鶯吟燕舞，
算潮水知人最苦。

滿汀芳草不成歸，日暮，
更移舟向甚處。

Xinghua tianying, *"Apricot blossom and heavenly shadows"*

Green silks hang sweeping the love-birds' shores,
I imagine that time the singing girl, Peach-Leaf,
called for the ferry.

Again my sad eyes meet the spring wind: About to depart,
I lean on the magnolia oars — Again a brief halt.

On the road to Chin-ling, Orioles sing and swallows dance.
Surely the tide knows my deepest sorrow.

Fragrant grasses cover the river banks but I have not managed to
return home. The sun sets,
Again I set the boat moving — toward what place?

【曲目五】

長亭怨慢

漸吹盡、枝頭香絮，是處人家，綠深門戶。

遠浦縈回，暮帆零亂向何許。

閱人多矣，誰得似長亭樹。

樹若有情時，不會得青青如此。

日暮，望高城不見，只見亂山無數。

韋郎去也，怎忘得玉環分付。

第一是早早歸來，怕紅萼無人為主。

算空有并刀，難翦離愁千縷。

Changting yuanman, *"A slow song about discontentment at the post-pavilion"*

Little by little the fragrant fleece of the branches is blown away;
Everywhere doors, are hidden behind thick green shades.

Going round and round the distant shores,
Where do the evening sails scatter to?

I have met many people,
Who could be compared to the trees at the Post-Pavilion?

If trees had feelings,
They could not still be green and green like this.

At sunset I look toward the high city wall but cannot see it,
I see only scattered countless mountains.

Wei Kao has gone, How could he forget Jade-ring's demands?

Of which the first is ： "Return very soon
Lest the red calyx has no one to be her master."

Even with the sharp shears of Ping-chou,
It's hard to cut the thousand threads of grief at separation.

【曲目四】

醉吟商小品

又正是春歸，細柳暗黃千縷，暮鴉啼處。

夢逐金鞍去。

一點芳心休訴，琵琶解語。

Zuiyin shang xiaopin, "*A short song set to the melody of 'Drunken Singing' in the Shang mode*"

Just now is again the time of spring's departure;
The delicate willows are a thousand threads of dark yellow;
On which the evening crows caw.

My dreams follow his golden saddle;

Oh, my heart, stop complaining so!
The lute understands human speech.

【曲目三】

鬲溪梅令

好花不與殢香人，
浪粼粼。

又恐春風歸去、綠成蔭，
玉鈿何處尋。

木蘭雙槳夢中雲，
小橫陳。

漫向孤山山下、覓盈盈，
翠禽啼一春。

Gexi meiling, "*Spring blossom in lone hill*"

Lovely blossoms are not here for the man who would dote on their fragrance,
Waves sparkle.

And I fear, when the spring wind departs
and the green shade will be complete —
Where shall I find the jade hairpins?

On a pair of magnolia oars, through the clouds in a dream,
I lie down stretched out for a little while.

In vain I seek beauty below lone hill,
The bluebird will sing for the whole spring.

【曲目二】

揚州慢

淮左名都，竹西佳處，解鞍少駐初程。

過春風十里，盡薺麥青青。

自胡馬窺江去後，廢池喬木，猶厭言兵。

漸黃昏，清角吹寒，都在空城。

杜郎俊賞，算而今、重到須驚。

縱豆蔻詞工，青樓夢好，難賦深情。

二十四橋仍在，波心蕩、冷月無聲。

念橋邊紅藥，年年知為誰生。

Yangzhouman, *"A slow song about Yangzhou"*

In this most famed city the south of Huai,
At Bamboo-west Pavilion, a beautiful place,
I unstrap the saddle for a brief halt at the first stage.

Through ten miles in the spring wind,
There is nothing but green shepherd's purse and wheat.

Since Tartar horses left from spying on the Yangtze,
Abandoned ponds and lofty trees,
Still detest talk of warfare.

Gradually it becomes twilight,
A clear horn blows out of the cold, In the empty city.

Tu Mu, the eminent connoisseur,
Were he to return today, could not fail to be astonished.

Though his poem on the cardamom was skillful
And his dream at green mansion was lovely,

He would find it hard to express these deep feelings.
His twenty-Four Bridges still exist,
Waves stir at midstream — the cold moon makes no sound.

I pity the peonies beside the bridge,
For whom do they grow year after year?

十首曲詞及翻譯

【曲目一】

淡黃柳

空城曉角，吹入垂楊陌。

馬上單衣寒惻惻。

看盡鵝黃嫩綠，都是江南舊相識。

正岑寂，明朝又寒食。

強攜酒，小橋宅。

怕梨花落盡成秋色。

燕燕飛來，問春何在，唯有池塘自碧。

Dan huangliu, *"Pale and yellow willows"*

In the desolate city the daybreak horn
Blows through the street of hanging willows.

On horseback in thin clothes, I feel the piercing cold.

Everywhere I see pale yellow and tender green —
All are my old acquaintances here in the River's South.

For the moment I am lonely,
Tomorrow is again the Cold Food Festival

With an effort I carry wine to the house near the small house by the bridge,

I fear when the last pear blossom falls, all is autumn color.

The flying swallows come, Asking where spring stays —
There is only the green of the pond.

四
—
聲樂重構篇

敲一葉凌波縹緲過三十六離宮遣遊人回首

猶有畫船障袖青樓倚扇相映人爭秀翠翹光

欲溜愛著宮黃而今時候傷春似舊蕩一點春

忪如酒寫入吳絲自奏問誰識曲中心花前友

角招

甲寅春予與俞商卿燕遊西湖觀梅于孤山之西村玉雪照映吹香薄人已而商卿歸吳興予獨來則山橫春煙新柳被水遊人容與飛花中悵然有懷作此寄之高商卿善歌聲稍以儒雅縐飾予每自度曲吟洞簫商卿輒歌和之極有山林縹緲之思今予離憂商卿一行作吏殆無復此樂矣

（五）煞聲　（仮）寄煞　簫笛音尺

為春瘦何堪更繞西湖盡是重柳自看煙外岫

記得與君湖上攜手君歸未久早亂落香紅千

吹盡也幾時見得

相憶長記曾攜手憂千樹壓西湖寒碧又片片

歎寄與路遙夜雪初積翠尊易泣紅萼無言耿

【曲目九】

暗香

辛亥之冬予載雪詣石湖止既月授簡索句且徵新聲作此兩曲石湖把玩不已使工妓隸習之音節諧婉乃名之曰暗香疏影

(九)煞聲 寄煞 簫筒音合

舊時月色算幾番照我梅邊吹笛喚起玉人不

管清寒與攀摘何遜而今漸老都忘卻春風詞

筆但怪得竹外疏花香冷入瑤席江國正寂寂

猶記深宮舊事那人正睡裡飛近蛾綠莫似春

風不管盈盈早與安排金屋還教一点隨波去

又卻怨玉龍哀曲等恁時重覓幽香已入小窗

橫幅

【曲目八】

疏影

（六）熬聲（尺）（五）夆熬　簫笛音合

苔枝綴玉有翠禽小小枝上同宿客裡相逢籬

角黃昏無言自倚脩竹昭君不慣胡沙遠但暗

憶江南江北想佩環月夜歸來化作此花幽獨

見依依故人情味似怨不來游擁愁聚十二一

立聊復爾也孤負幼輿高志水涵晚漠漠搖煙

奈未成歸計

徵招

（仕）煞聲　（五）寄煞　簫笛音尺

潮面卻過西陵浦扁舟僅容居士去得幾何時

桑離離如此客途今倦笑漫贏得一襟詩思記

憶江南落帆沙際此行還是迤邐到中山重相

算潮水知人最苦滿汀芳草不成歸日暮更移

舟向甚處

杏花天影　丙午之冬、發沔口丁未正月二日道金陵北望淮楚風日清淑小舟

挂席容與波上　　（仅）簫聲　（出）（仉）寄熬　簫筒同音尺

綠絲低拂鴛鴦浦想桃葉當時喚渡又將愁眼

與春風待去倚蘭橈更少駐金陵路鶯吟燕舞

見只見亂山無數韋郎去也怎忘得玉環分付

第一是早早歸來怕紅萼無人為主算空有并

刀難剪離愁千縷

【曲目五】

長亭怨慢

予頗喜自製曲初率意為長短句然後協以律故前後闋多不同桓大司馬云昔年種柳依依漢南今看搖落悽愴江南潭樹猶如此人何以堪此語予深愛之

（六）煞聲　（五）（尺）寄煞　簫箇音上

漸吹盡枝頭香絮是處人家綠深門戶遠浦縈

回暮帆零亂向何霧閱人多矣誰得似長亭樹

樹若有情時不會得青青如許日暮望高城不

【曲目四】

醉吟商小品

(六)煞聲 (乙)(八)寄煞 簫筒音上

又正是春歸細柳暗黃千縷夢鴉啼霧夢逐金

鞍去一點芳心休訴琵琶解語

西溪梅令

(尺)煞聲　(五)寄煞　簫簡音　合

好花不與殢香人浪粼粼又恐春風歸去綠成

陰玉鈿何壽尋木蘭雙槳夢中雲小橫陳漫向

孤山山下覓盈盈翠禽啼一春

厭言兵漸黃昏清角吹寒都在空城杜郎俊賞

算而今重到須驚縱豆蔻詞工青樓夢好難賦

深情二十四橋仍在波心蕩冷月無聲念橋邊

紅藥年年知為誰生

【曲目二】

揚州慢

淳熙丙申至日予過維揚夜雪初霽薺麥彌望入其城則四顧蕭條寒水自碧暮色漸起戍角悲吟予懷愴然感慨今昔因度此曲千巖老人以為有黍離之悲也

（六）然聲　（工尺）寄然　　簫笛音上

淮左名都竹西佳處解鞍少駐初程過春風十

里盡薺麥青青自胡馬窺江去後廢池喬木猶

空城曉角吹入垂楊陌馬上單衣寒惻惻看盡

鵝黃嫩綠都是江南舊相識正岑寂明朝又寒

食強攜酒小橋宅怕梨花落盡成秋色燕燕飛

來問春何在唯有池塘自碧

白石道人歌曲重構用譜

張麗真手抄

【曲目一】

淡黃柳

客居合肥南城赤闌橋之西巷陌淒涼與江左異唯柳色夾道依依可憐因度此闋以紓客懷

(凡)煞聲 (五)(凡)寄煞 簫簡音上

板× 鼓。 停聲待拍 ⊗

鴟夷翩然引去浮雲安在我自愛綠香紅舞容與

一人丁以夂ㄅㄅ

看世間幾度今古　盧溝舊曾駐馬爲黃花閑吟

ム丂丩久ㄣㄣㄇ一マ台一幺人一丁ㄨㄨ久ㄥ

秀句見說胡兒也學綸巾欹羽玉友金蕉玉人金

人一以丁幺丁以久ㄇㄣ夂以夂ㄇㄥ

縷緩移箏柱聞好語明年定在槐府

暗香仙呂宮

辛亥之冬予載雪詣石湖止既月授簡

索句且徵新聲作此兩曲石湖把玩不

已使工妓隸習之音節諧婉乃名之曰

工俟一本已二妓盡即工之謌袂作

此用郭林宗折巾墊雨故事

歸字爲而方誤可證

白石悼石開詩有尚

留中聲角胡魔有

知音之而正与此調

翠典用爰相同

攷石湖詩束有

盧洋崇賓館二

詩又有蹋鴟中一

貪韻之俣知白石

觀義結佽石湖詩

中說他句出乃戈

民順卯不如戈

妄改胡字不如諦審

污已疎于改右巳

白石道人像

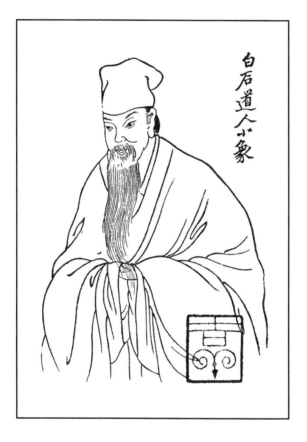

三

圖譜篇

（二）宋・張炎：《詞源》。

（三）夏承燾：《唐宋詞論叢》（香港：中華書局，1985年）。

（四）夏承燾：《夏承燾集》第八冊（杭州：浙江古籍出版社，1998年）。

（五）楊蔭瀏、陰法魯：《宋姜白石創作歌曲研究》（北京：音樂出版社，1957年）。

（六）丘瓊蓀：《白石道人歌曲通考》（北京：音樂出版社，1959年）。

（七）洛地：《詞樂曲唱》（北京：人民音樂出版社，1995年）。

（八）鄭孟津：《宋詞音樂研究》（北京：中國文史出版社，2004年）。

伴奏的樂器

說到詞唱的伴奏樂器，白石的詞序中曾提到用簫、笛、啞觱篥、琵琶，甚至用古琴伴奏。

至於擊節按拍，依《詞源》的說法，可用板、鼓以至手、足。我們覺得白石詞清空的意境，可用琴、簫伴奏，以板、鼓按拍擊節，試唱之後，效果不錯。

是「擬唱」不是「復古」

溫故而知新，詞樂大部分經已亡佚，其唱法亦已失傳，我們的「擬唱」只能算是一種探討，一種實驗，或甚至是漢語演唱一種復古形式的創新。通過這種擬唱，我們最少可以更深入了解漢語演唱的特點及其審美要求：漢語唱腔的形成，是字音的延伸；其節奏，則是文句字、逗、句、韻的自然停頓；其追求的藝術效果，則是文學作品的情思、意境在音樂中的呈現。

想進一步了解詞唱，可參考下列各書：

（一）宋·姜夔：《白石道人歌曲》。

（四）由於大曲、法曲必有散序，《詞源·拍眼》說：「惟法曲散序無拍，至歌頭始拍。」估計詞唱當亦有散起方式。參照南北曲的散起方式可有三種：或以一字，或以一逗，或以一句。

（五）法曲在終曲時有「煞袞」的節奏形式。《詞源·拍眼》說：「前袞、中袞，六字一拍，要停聲待拍，取氣輕巧；煞袞則三字一拍，蓋其曲將終也，至曲尾數句，使字悠揚，有不忍絕響之意，以餘音遠梁為佳。」詞樂雖無「煞袞」形式，但在終曲時，亦應如南北曲那樣，放慢、唱散以結。

（六）除了令詞，多有兩片，「過片」的節奏應該如何處理，《詞源·製曲》一章有一些提示：「過片不要斷了曲意，須要承上接下。如姜白石詞云：『夜涼獨自甚情緒』，於過片則云：『西窗又吹暗雨』，此則曲之意脈不斷矣。」此處所論的雖是「曲意」的「意脈」不斷，那麼作為運腔演唱的「氣脈」亦應不斷。當代詞曲理論家洛地認為，過片時，上片結句可逐漸唱散，慢慢連接下片首句；連接處音斷而氣不斷，要到下片第一韻處始起拍。我們試作這種處理，果然覺得氣脈不斷，在節奏上達到承上接下的效果。

時，以停頓（住）的方式將兩音分開，中按一拍，這種停頓叫「丁住」。是一種藝術處理，也是「取氣」一法。

大住小住的按拍一般是句、韻之所在。《謳曲旨要》第四條說：「頓前頓後有敲捎，聲拖字拽疾無勝。抗聲特起直須高，抗與小頓皆一捎。」有時，為加強藝術效果，延長音的「大頓」或「小頓」前後都按拍，在其前按拍（用鼓擊或用手拍）叫「打前拍」（見《詞源》「拍眼」）；在其後按拍叫「打後拍」（同前）。「抗聲」指音調冒高處，亦要按拍顯示。這類按拍，都不是句韻所在的「官拍」，處理上有一定的彈性，視唱者對樂曲的了解而定。

按照《詞源》的理論及所定的規範，我們嘗試這樣處理姜詞譜的節奏：

（一）定「官拍」：凡韻字所在必有官拍，且多是「大頓」或「小頓」之後停聲待拍，以板擊之。

（二）「眼」依《詞源》所提示的幾個要點及姜詞譜的節奏符號定眼位，但也會按詞的意境、字聲及唱腔略予調整增刪，以鼓點表示。

（三）按詞意的情緒定基本拍的長度，「大頓」按基本拍的倍數延長，如作某種藝術處理時，其延長可作彈性處理。「小頓」的延長時間約等於「大頓」之半。

（一）官拍、艷拍（或花拍）

（二）敲、揞、鞁、板

（三）大頓、小頓

（四）大住、小住、丁（打）住

《謳曲旨要》第一條說：「歌曲合曲四揞均，破近六均慢八均。官拍艷拍分輕重……」官拍是韻字所在的拍位，是必要的、規定的拍，所以叫「官拍」，類似崑曲中的「正板」。一首「小令」(篇幅最短的詞) 有四官拍，「近」詞有六官拍，「慢」詞有八官拍。在字、逗、句或某種藝術處理需要上所增加的拍叫「艷拍」，也稱「花拍」。通常是官拍重擊，艷拍輕打。以鼓擊拍叫「敲」，以手按拍叫「揞」，以腳打拍叫「鞁」。官拍一般以板按。

《謳曲旨要》第二條說：「大頓聲長小頓促，小頓才斷大頓續。大頓（作者按：疑為「大住」）小住當均住，丁住無牽逢合六。」「頓」是字腔的延長，「大」是較長的延長音，「小頓」是較短的延長音。「住」是停頓。大住小住都在韻字之後，其後即按拍，也就是所謂「停聲待拍」，是詞唱節奏最明顯最基本的部分。

至於「丁住」是遇到前一音與後一音相差一個八度，如由「合」(低八度SO) 到「六」(SO)。

逗，則板眼可從句逗而生；雖似無定，而實則大致有定也。

「句逗」（包括：字、逗、句、韻）不但是詞作為一種詩體的「語法節奏」，而且是蘊含情感起伏的「情緒節奏」。前者依詞調的文字格式而有所規定，後者則按唱者對詞意（情感和意境）的不同了解作彈性處理。對演唱來說，「情緒節奏」無疑更為重要，故中國古代唱譜的拍眼都採取一種「寬鬆」的記法，留給唱者更多發揮的空間。據楊、陰二氏的統計研究，姜白石十七首詞譜所用的三個拍眼譜號，落於韻、句、逗處者共二百一十一次，其中落於韻處最多，有一百三十三次，而落於非句逗處者僅四十次。[5]，可見製曲者對唱者的節奏規定是非常寬鬆的。這種寬鬆的拍眼記法，也是中國傳統演唱音樂節奏觀的特點所在，因此直到明清南北曲文人系統曲譜如《納書楹曲譜》、《吟香堂曲譜》等的拍眼記法，仍只記頭板和中眼。

詞的演唱發展至南宋，已非常成熟，拍眼的理論和規範也豐富了。張炎《詞源》的《謳曲旨要》八條，前四條與第六條都是論拍眼的。有下面這些名目：

此。我們認為還是應該就宋代文獻的說法加以探討。其中，張炎《詞源》「拍眼」一章所論應該是最重要的依據：

> 法曲、大曲、慢曲之次，引、近輔之，皆定拍眼。蓋一曲有一曲之譜，一均有一均之拍。若停聲待拍，方合樂曲之節。所以眾部樂中用拍板，名曰「齊樂」，又曰「樂句」，即此論也……曲之大小皆合均聲，豈得無拍？……唱曲苟不按拍，取氣決是不勻，必無節奏，是非習於音者不知也。

所謂「拍」或「眼」，都是指樂曲中以板、鼓或手擊節的位置。所以要「按拍」，是為了在演唱過程中「取氣」均勻，顯出規律性的節奏。詞作為一種律曲，其「拍」依曲文的字、逗、句、韻而按，因為這都是漢語誦讀時最自然的停頓、換氣或延長的位置。所以把按拍的觀念叫做「齊樂」或「樂句」是很合適的，那等於文句上的標點。故楊蔭瀏的另一個觀點 4 比較合理：

> 詞調之板眼，由句逗至頓挫而來；調雖未記明板眼，詞則原已暗有句逗；詞有句

4 楊蔭瀏、陰法魯：《宋姜白石創作歌曲研究》（北京：音樂出版社，1957年），頁41。

獻固應存其原音，唱者的唱譜，實可斟酌修改。

我們雖認為可以依照前引何氏這種理解去處理白石詞的唱腔，但我們也同時認識到南宋詞唱，還沒有達到明、清南曲，尤其是海鹽腔、崑山腔一字多腔，「一字之長，延至數息」那種流麗婉轉。而且以姜詞清空的風格，也不宜有太多裝飾音。把現在所見譯譜的「有定工尺」試唱，即不加潤腔，旋律仍然優美動聽，古意悠然。王力擬構的宋音，音素結構比明、清南北曲字音還要豐富複雜，唱者若能講究出字、落音、歸韻即明，明代沈寵綏所謂「頭、腹、尾」，字腔的音樂趣味即可融於旋律之中，追求沈括所謂「聲中無字，字中有聲」之境。

「樂句」的節奏觀

姜詞譯譜比較有爭論性的問題是節奏問題。儘管俗字譜（宋代所用簡化、草化的工尺譜）中幾個記節奏的譜號，各家的解釋沒有太大的分歧，但這類節奏符號其實只有三個，難以體現完整的節奏框架。像楊蔭瀏用西方音樂的四四拍子和小節線方式，來記節奏還是頗有爭議。即使用崑曲的慢板板式（一板三眼）來了解也還是不大妥當。詞樂的節奏似乎比崑曲更自由

跟着談到腔。由於各家所譯的白石詞譜，大致都是一字一音，有人就懷疑：所謂「永言」、「長言」的唱法如何在詞樂演唱中體現。現代學者何靜源的意見很值得參考：

凡屬於協律的詞調或曲牌，在它的旋律內容裏，有其統一性或共性的部分，也有其差異性或個性的部分。換句話說，就是：一首可唱的詞曲的樂譜是由兩部分的工尺組成的，一部分是受限定的有定工尺；一部分是不受限定，可由製譜者自由採用的工尺。前者就是旋律的共性部分，後者就是它的個性部分。[3]

何氏所言本是南北曲製作的通例，曲既與詞一脈相承，以「有定工尺」觀念去了解白石詞譜的一字一音應該是可通的。各家譯出來的白石詞譜，其實只是「有定工尺」，即曲唱所謂「主腔」部分；至於「潤腔」部分，便由編曲者或演唱者按自己的體會來彈性處理。當然「潤腔」部分的「無定工尺」，仍不能違背字聲的規律。姜白石在《長亭怨慢》小序云：「予頗喜自製曲，初率意為長短句，然後協以律⋯⋯」白石為聲律大家，為詞配腔，講究四聲諧協，但不無瑕疵。如《淡黃柳》「馬上單衣」句，組成「單衣」一詞的「單」、「衣」二字均為陰平字，「單」字配「五」（la），「衣」字則配低一律的「六」（so），唱而聽之：「單衣」便似「單意」。文

3 引自夏承燾：〈說姜夔十七譜的「有定工尺」〉，《唐宋詞論叢》（香港：中華書局，1985年），頁159。

但從元、明以來的「曲音」理論（如周德清《中原音韻》、王驥德《曲律》等所論）看，詞曲演唱所用的字音，並不如實反映某一時一地的語音，而是大抵可通南北四海，帶有一定時代色彩和人為成分的字音。那麼唱宋詞也不必要求用真正的宋音來唱。然而，為了使字音與樂音結合得更好，有助於美聽，我們不妨用現、當代語音學家擬構的「擬宋音」來唱。

王力《漢語語音史》第六章，根據朱熹的《詩集傳》、《楚辭集注》所用的宋音反切資料和大量宋詞韻字資料，整理出宋代的聲母和韻部，並有宋詞韻字的標音舉例，正好為我們試唱宋詞的探討提供了條件。清代詞學家戈載說：「唐段安節《樂府雜錄》有五音二十八調之圖：平聲，羽七調；上聲，角七調；去聲，宮七調；入聲，商七調……隨律押韻，更隨調擇韻。」《《詞林正韻‧發凡》）詞之用韻與宮調的配合有嚴格規定，而節奏上的主要拍位亦在韻字上。所以，演唱宋詞，找出靠近宋音的韻字讀法是很重要的。以王力擬構的宋音檢視十七首有旁譜的白石詞，韻字的標音絕大部分屬同一韻部。這就使我們確定可以用王氏的擬宋音試唱。二〇〇四年我們試唱的成果，由香港浸會大學中國語文及文學系出版了光碟，效果不錯，但有個別字的擬音有待斟酌。二〇一〇年，王力弟子郭錫良出版了《漢字古音手冊》修訂本（北京：商務印書館），收字一萬一千七百餘個，除標出上古音外，還同時標出《廣韻》和《集韻》的字音。為我們修訂所用的擬宋音提供了方便，因為郭錫良的研究，是以王力的研究為基礎的。此次試唱所用擬宋音，略有修訂。

塊⋯⋯古人謂之『如貫珠』，今謂之『善過度』是也。」（《夢溪筆談・樂律一》）這已是極高層次的美學，可以想像宋代最優秀的演唱已達到怎樣一種水平。沈括的觀點一直被元、明、清的曲家引用，成為漢語演唱一個追求的目標。

字與腔的處理

宋人對字音與唱腔的關係已有這樣深刻的認識，用甚麼字音來唱宋詞便成為我們要探討的第一個問題。按照依字行腔的原則，宋詞自當用宋音來唱才能達到最佳的藝術效果。但遺憾的是，儘管在沈約等建立了漢語聲韻學之前已發明了「反切」拼音法，到宋代將近一千年，中國依然未發展出一套更科學的注音符號。「反切」法以二字急讀切出第三字字音，往往會因前二字地方讀音的差別，切出的第三字字音各有不同。那是由於中國語音沒有統一，各地方音差別很大。宋詞襲用《切韻》系統的「詩韻」，「詩韻」是官方所定應制用的音系（以《禮部韻略》、《廣韻》、《集韻》為代表），有相對的穩定性。但詞因為還不被承認為正統的詩體，用韻並不如詩嚴謹，有時就雜用方音。即使緊跟「詩韻」，有反切可依，宋代口語語音已有很大的變化，反切所得的結果各地也會不同。所以從實際來說，想以宋音唱宋詞，根本是不可能的。

・九二

正如前面所述，漢語演唱音樂，以文學語言為主導，很重視文字聲韻的美，文字聲韻之美成為主體部分，樂音之美，必須與之配合，才能發揮作用。明代曲家魏良輔說：「五音以四聲為主，四聲不得其宜，則五音廢矣。」詞唱的理論早已提倡此說。南宋詞人張炎《詞源·謳曲旨要》謂：「腔平字側莫參商，先須道字後還腔。」其觀念可追溯到《尚書·舜典》的「歌永言，聲依永，律和聲。」所謂「歌」，就是「言」的延長。詞、曲中的所謂「腔」，也就是字音的延長。字音延長後所成音列，其高低音的組合，受四聲音勢的制約。字音的延長叫做「字腔」，依字腔音勢配以音樂，謂之「唱腔」。唱腔跟字腔走，必須與字聲的平仄調值、音高走勢配合。一個仄聲字，不能以平聲的腔來配；先要把字的四聲音勢出來，知道是那一聲，才可以延長，才可以配樂成腔。

除了張炎，宋代著名音樂家陳元靚《事林廣記·遏雲要訣》把依字行腔的要求講得更具體：「腔必真，字必正：欲有墩、亢、掣、拽之殊，字有唇、喉、齒、舌之異；抑分輕清、重濁之聲，必別合口、半合口之字。」講到腔的抑揚頓挫，與字的發音部位，字調的高低、字音輕重清濁，都有極密切的關係。宋人之所以這麼強調字音與腔的關係，原因是字音的審美價值，從沈約的發現經近千年的實踐，已被充分肯定：字音與樂音在演唱中融為一體，已成為宋代聲樂最高的審美要求。宋代學者沈括說：「古之善歌者有語：『當使聲中無字，字中有聲。』……字則喉、唇、齒、舌等音不同，當使字字輕圓，悉融入聲中，令轉換處無磊

體、較接近史實的推想。2

我們主要探討的是第四項。

宋詞擬唱的理論依據

就文獻看來，詞的演唱在南宋已發展到高峰，不但有專業的唱者（歌妓），而且也形成了規範和審美的標準，其理論一直影響到宋、元、明、清南北曲的演唱。可以說，宋以後的散曲、劇曲的演唱，其規範及審美的源頭就是詞唱。

詞樂由胡樂轉化為漢樂，其演唱要求和審美標準逐漸向傳統詩歌演唱靠攏，最後發展為曲的演唱，成為漢語演唱藝術最有代表性的一種方式。

2 「關於第一至第三點，可參考夏承燾：〈論姜白石的詞風〉，《姜白石詞編年箋校》（上海：上海古籍出版社，1998年），頁 10-11。

對文字聲韻的要求，幾近於元明的曲家。講求聲韻的結果是詞律的形成，於是詞便成為一種

長短句的律體詩，即使不配上音樂，也具有很豐富的音樂效果。於是詞作為一種詩體便漸漸

可以脫離音樂而獨立；不懂音樂的文人，亦可「倚聲（字聲）」填詞，視為一種純文學的詩體。

詞樂（尤其是原來的樂調）的湮沒，未嘗不與此有關。詞體的形成從樂調開始，從脫離音樂結

束．；對詩來說是一種成果，從樂來說無疑是一種損失。

從白石詞譜了解詞樂

現在我們還可以看到的詞樂樂譜，就只有宋姜夔（白石）記下旁譜的十七首詞和明·王驥

德偶見文淵閣藏《樂府大全》（又名《樂府渾成》）刻本而錄下來的《婍聲譜·小品》二首。其中彌

足珍貴的是姜譜。其文獻價值有幾方面：

（一）保留了詞樂的多種形式及其製作的不同方法。

（二）反映了詞樂的不同來源。

（三）可讓我們了解詞的成熟階段詩與樂結合的情況，尤其是如何被納入了以文字聲韻為
主導的漢語演唱音樂系統。

（四）把這些樂譜和宋代有關詞樂理論的文獻結合研究，可以對詞樂的演唱方法作較具

古、新疆一帶少數民族的音樂。音樂形式的不同，也造成了詩歌形式的變化。

以文學語言為主導的漢語演唱

但漢族的演唱音樂，始終以文學和語言文字為主導。自齊、梁時沈約等創「四聲」之說，「字含宮商」的思想便成了中國演唱音樂重要的審美原則。沈約認為，字音的美聽效果，比樂音要豐富得多。他說：「宮商之聲有五，文字之別累萬。以累萬之繁，配五聲之約，高下低昂，非思力所舉。又非止若斯而已也，十字之文，顛倒相配，字不過十，巧厤已不能盡，何況復過於此者乎？」（《答陸厥書》）因此，詞樂作為一種演唱音樂，在漢化的過程中，必然逐漸靠近重視文字聲韻的審美標準，把文字聲韻的美聽效果，納入詞的製作與演唱之中。

沈約又說：「文章之音韻，同弦管之聲曲，則美惡妍蚩，不得相乖反。」（同前）詞的填寫，為了和「弦管之聲曲」配合，較之絕、律詩更講究聲韻。絕、律只論平仄，詞已重視四聲，甚而清濁、陰陽。詞人姜白石說：「七音之協四聲，各有自然之理。今以平入配重濁，以上去配輕清，奏之多不諧協。」（《大樂議》）像周邦彥、姜白石、張炎這些精於音律的詞人，

溫故知新——宋詞「擬唱」的再探討　古兆申

詞作為一種詩的形式和其他傳統詩體（如絕詩、律詩）有下面四點不同：

（一）每首詞都有一個與音樂有關的調名，叫做「詞牌」，如《念奴嬌》、《水調歌頭》等等。

（二）除了最短的「令」詞不分「片」之外，較長的詞都分「片」。「片」亦作「遍」，就是同一樂調重複一遍，填上不同的詞，詞意與前一片相連成為一個較長的作品。

（三）每個詞調都有一定數目的句子，每句字數、每字的聲調、韻字的位置都有定。

（四）句子字數參差不齊，打破了漢魏以來五、七言詩的基本句式，形成所謂「長短句」。[1]

所以有這四方面的不同都和音樂有關。其他傳統詩體都是先有詩後有樂；詞的形成過程卻倒過來，先有樂後有詩。而且詞的音樂主要來自隋唐以來西北方的「胡樂」，也就是現在蒙

1　「長短句」一詞，在歷史不同時期有不同概念。在詞體未形成時，「長短句」曾用來指「七言詩」和「五言詩」：「七言」謂之「長句」，「五言」謂之「短句」。後「長短句」又被用來稱呼句法參差的詞。可參考施蟄存《詞學名詞釋義》（北京：中華書局）頁9，〈長短句〉一章。

饒公指出的「但憑理校」、「迄無古本可資尋勘」，正是清末以來研究《白石道人歌曲》的一大障礙。無相本的發現，向今人提供了最接近陶抄古本面目的版本，必將宋詞音樂的校勘、考證和擬唱引入新的境界，而我們的眼福，也足以傲視當年的樊榭山人和揚州二馬了。9

二〇一二年九月廿一日

文中所引樓敬思《洗硯齋集》傳本至罕，去夏黃裳先生從來燕榭藏書中親為檢出複印，囑陸灝先生寄示，意良可感。惟該集並無序跋，《來燕榭書跋》定為乾隆槧本，《清代版刻一隅》歸入雍正間刻本，不知孰是。若以張奕樞刻本序言「壬子春客都門，與周子畇餘過澹慮汪君邸舍，見案頭有《白石道人歌曲》六卷《別集》一卷，係陶南邨手鈔本，而樓觀察敬思所珍藏者也」數語衡之，似以雍正為妥，蓋乾隆間樓氏已得陶鈔《白石道人歌曲》，斷無再嘆「不能如石帚諸君子尋宮數調」之理。惜黃裳先生於本月五日仙逝滬上，已不堪重問矣。九月廿二附記。

9 無相本收入《白石道人歌曲補箋》，即將出版。

睨當時的江南文壇。其中在無相本上留下校語的厲鶚、閔崋、王藻都不是鹽商：揚州二馬、

張四科、陸鍾輝雖然不是鹽商，但生意都沒有到「總商」的地步，遠遠談不上甚麼「揚州鉅商」。

推動《白石道人歌曲》刻本問世的靈魂人物，應該還是主盟浙西詞壇的厲鶚。謝章鋌《賭棋山

莊詞話》說的很恰當：「雍正、乾隆間，詞學奉樊榭為赤幟，家白石而戶梅溪矣。」而陸鍾輝

序刻《白石道人歌曲》，很可能是由於他擁有過一個刻書作坊「水雲漁屋」，刊刻的圖書，無論

是自撰的《放鴨亭小稿》、自輯的《南宋羣賢詩選》，還是陸龜蒙的《笠澤叢書》、姜白石的《詩

詞合集》都很精美。連收清代刻本至為嚴苛的《中國版刻圖錄》也收入了他刻的幾部書。

我們看到無相本的校語，就明白張文虎對《白石道人歌曲》陸鍾輝刻本的揣測站不住脚

了。陸刻絕不是哪個「鹽獃子」附庸風雅的產物，而是厲鶚主盟的浙西詞派和維揚二馬主導的

韓江雅集寄興咏吟、聯結常課之外的用心之作。饒宗頤先生在《白石旁譜新詮‧後記》中總結

過去一百年校勘家整理《白石道人歌曲》的業績時說：

姜譜繫詞樂之一線……自張文虎、鄭大鶴至於夏君，而臻其極摯，惜《白石詞集》

迄無古本可資尋勘，各家傳抄，時復乖牾，若舒藝室喜以己意改字，尤足詬病；而鱗

爨之術，但憑理校，如以上下片互勘，為例雖嚴，而事不盡爾，譬猶《詞律》以上下

半定平仄，未見其果可據也。

既逾月，吳中寫眞葉君震初適來，輩貌小像，合爲一卷，方君環山補景，命曰《九日行菴文讌圖》。裝池成，將各書所作於後，而屬鵷爲之記。按圖中共坐短榻者二人：

右箕踞者，爲武陵胡復齋先生期恆；左抱膝者，爲天門唐南軒先生建中也。坐交牀者二人：中手牋者，歙方環山士庶；左仰首如欲語者，江都閔玉井華也。一人坐藤墊撚髭者，鄞全謝山祖望也。一人倚石坐，若凝思者，臨潼張漁川四科也。樹下二人：離立把菊者，錢唐厲樊榭鶚。袖手者，錢唐陳竹町章也。一人憑石牀坐撫琴者，江都程香溪先生夢星也。聽者三人：一人垂袖立者，祁門馬半槎曰璐；二人坐瓷墊，左倚樹、右跂腳者，歙方西疇士廉、汪恬齋玉樞也。二人對坐展卷者，左祁門馬嶰谷曰琯、右吳江王梅沜藻也。一人觀者，負手立於右，江都陸南圻鍾輝也。從後相倚觀者一人，歙洪曲溪振珂也。此十六人者，或土斷，或客遊，聚散不常。異日者，歲月遷流，撫節物以有懷，一披此圖，怳如晤對。將來覽者，或亦不異此意乎！

參加雅集的十六人大體上包含三類：第一類是以胡期恆、全祖望、程夢星爲代表的罷官文人。比如程夢星的姨丈胡期恆被雍正帝視爲「年黨第一人」，在甘肅巡撫任上被革職，成爲康熙、雍正兩朝政權交替中高層政治角逐的見證。第二類是以厲鶚、陳章爲代表的寒士詞人。所有十六位都名載地方志書，其中十第三類是以維揚二馬、張四科、陸鍾輝爲代表的鹽商。

位國史有傳。從任何角度講，這個由浙江詞人和他們的揚州贊助人爲主導的聚會，都足以睥

· 八四

以親檢無相本原卷，發現書眉校語屢見「樊榭云」、「玉井云」、「梅汌云」的字樣，其中樊榭就是浙西詞派領袖厲鶚厲樊榭，玉井就是揚州閔華閔玉井，梅汌就是吳江王藻王梅汌。這幾位詞人正好都是韓江雅集的成員。回港後，我又將無相本與鮑廷博三色手校張奕樞本對校一次，發現鮑氏朱筆校語所據「維揚馬氏底本」的譜字行格與無相本全同，說明在符藥林將京師樓敬思收藏的陶抄本傳到揚州的時候，韓江雅集成員對該本進行了反覆的校讀。

這引發我進一步聯想到美國克利夫蘭美術館收藏的《九日行庵文讌圖》卷。該卷描繪了馬氏兄弟在行庵會友雅集的情景。行庵在揚州天寧寺西隅，由馬曰琯、馬曰璐兄弟出資購買。畫中馬氏兄弟及厲樊榭、閔玉井、王梅汌、陸鍾輝等人肖像神態各具。而雅集的時間在乾隆八年重九日，就是夏曆九月九日。繪圖的時間據厲樊榭的《九日行庵文讌圖記》，是在雅集之後「既逾月」，也就是十月九日之後。陸鍾輝序刻《白石道人歌曲》在同年十月既望，也就是十月十六日，則陸氏重刻《白石道人歌曲》與此圖繪成只差不足一週的時間，正可以看成是重刻《白石道人歌曲》時韓江雅集的「合影」，厲樊榭的這篇《圖記》涵蓋了韓江雅集的主要成員，寫得也很生動傳神，抄出來和大家一道欣賞：

乾隆癸亥九日，積雨既收，風日清美，遂約同人，咸集於斯。中懸仇英白描陶靖節像，採黃花，酌白醪為供。乃以「人世難逢開口笑，菊花須插滿頭歸」分韻賦詩。

因並《詩集》亟為開雕，公之同好。……《歌曲》第二卷、第六卷為數寥寥，因合為四

卷。其中自製曲俱有譜旁注，雖未析其節奏，悉依元本鈎摹，以俟知音識曲者論定云

爾。

乾隆癸亥冬十月既望，江都陸鍾輝書

陸鍾輝刻本問世之後，震驚詞壇。僅僅相隔六年，乾隆十四年（一七四九年）厲鶚的弟

子松江詞人張奕樞就據汪澹廬傳抄的陶抄本再刻《白石道人歌曲》。姜詞的愛好蔚然成風，

《白石道人歌曲》在清代反復被傳抄轉刻，直到民國三年（一九一三年）朱孝藏《彊村叢書》還

據江炳炎傳抄周晚菘抄本再一次付梓。從乾隆八年到民國三年（一七四三至一九一三年）的

一百七十年間，出現了幾十種重要的《白石道人歌曲》刻本、抄本，宋人詞集在清代刻本之

多，以姜詞為第一。

筆者校理姜詞，發覺《白石道人歌曲》在揚州首次重刊實非出於陸鍾輝一人之力，而是浙

西詞派和以維揚馬氏昆仲為核心的韓江吟社集體精心籌劃的結果。把韓江吟社和《白石道人

歌曲》聯繫起來的是一個新發現的抄本。這個抄本原是施蟄存先生無相庵舊藏，後歸楓江書

屋（以下簡稱無相本）。范景中先生曾為無相本寫過一篇題記；陳先行先生也曾鑒定過該本的

字跡和工料，認為是典型的乾隆初期江南抄本。去夏訪書滬上，承楓江書屋主人的美意，得

奉常所錄，未能盡見也。聲文之美，綮具此編。嘉泰壬戌，[8]刻於雲間之東巖，其家轉徙自隨，珍藏者五十載。淳祐辛亥，復歸嘉禾郡齋千歲令威，夫豈偶然！因筆之以識歲月。

端午日，菊坡趙與嵒書

元至正庚寅（一三五〇年），陶宗儀在杭州借到朋友葉居仲藏的錢刻傳抄本，請人抄錄。十年後在松江，自己又用善本校勘。清雍正年間，因政務往來於京師和贛粵的樓敬思發現了陶宗儀的這個抄本，但僅在流寓京師的江浙同調符藥林、周晚菘、汪澹廬數人之間傳抄，直到乾隆八年（一七四三年）陸鍾輝在揚州據陶抄重新刊刻《白石道人歌曲》，宋詞的聲文之美才廣為文人所知。陸鍾輝自序刊本云：

南宋鄱陽姜堯章，以布衣擅能詩聲，所為樂章，更妙絕一世。……自黃叔暘所輯《花庵絕妙詞選》二十餘闋外，流傳者寡；雖以秀水朱竹垞太史之搜討，亦未見其全，疑《白石道人歌曲》六卷著錄於貴與馬氏者，久為《廣陵散》矣。近雲間樓廉使敬思購得元陶南村手抄，則六卷完好無恙，若有神物護持者。予友符戶部藥林從都下寄示，

八一

一一五五至一二二一年），字堯章，號白石道人，是南宋重要的詞人，對於南宋後期詞壇的格律化有巨大的影響。康熙初年，朱彝尊《詞綜·發凡》謂：「詞至南宋，始極其工，至宋季而始極其變，姜堯章最為傑出。惜乎《白石樂府》五卷，今僅存二十餘闋也。」

按姜夔《白石道人歌曲》六卷，宋寧宗嘉泰壬戌（一二〇二年）冬至日，雲間錢希武刻於東巖之讀書堂。朱彝尊所謂《白石樂府》五卷，是根據陳振孫《直齋書錄解題》的著錄。六卷本卷一《皇朝鐃歌鼓吹曲》十四首、琴曲一首、卷二《越九歌》十首、卷三令三十二首、卷四慢二十首，卷五自度曲十首，卷六自製曲四首，又《別集》一卷十八首。其中詞調令、慢、近、犯十七首，旁綴字譜，流傳各本譜字多有訛誤，研究者看法不一；琴曲《古怨》一首，旁綴減字譜；十首《越九歌》旁綴律呂譜，標明絕對音高。詞調十七首中，《醉吟商小品》和《霓裳中序第一》的旋律是唐樂的片斷，《玉梅令》的旋律是范成大家樂工的作品，其餘多是白石自度。五十年後，宋理宗淳祐辛亥（一二五一年），錢希武刻本的書版歸鎮守嘉興的趙令威，宗室趙與訔為之撰寫跋文，補刊在錢刻本中⋯

歌曲特文人餘事耳，或者少諧音律。白石留心學古，有志雅樂，如《會要》所載，

惜乎樂譜不傳，音學已絕，宋儒先生未嘗不深思好學，而於俗樂輒置之不議，即雅樂亦無從討論矣。後世倚聲者不能如石帚諸君子尋宮數調。

這裏「石帚」，就是指姜夔。樓敬思在《書姜夔〈疏影〉詞後》文末，還流露出尋訪舊譜俾復聲文舊觀的憧憬：

　　宋修內司所刊《樂府混成》，類列宮調大小曲，具載有辭有聲。明《文淵閣書目》尚著其錄，安得此書出而一為考索乎？舊譜零落，為之慨然。

奇妙的是，在發出「不能如石帚諸君子尋宮數調」、「舊譜零落，為之慨然」的感嘆後不久，樓敬思的願望居然實現了。

《白石道人歌曲》在清代的重現

宋詞聲文之美碩果僅存的範例就保存在姜夔的《白石道人歌曲》之中。姜夔（公元

文」，可能恰是襯字，因此不必去為宋詞定譜式。6

施先生還認為：

　　詞中用字的平仄也不必太固定。宋人作詞甫即交歌女傳唱，她們如果覺得有不便於歌唱之處，自然會將仄聲改變為平聲的。去聲和上聲也是如此，她們會將上聲唱成去聲的。即如現代我們聆聽歌曲，歌者所唱均異於我們平時所讀。7

　　因此，他認為斤斤於平仄也沒意思，不主張現代詞學界再考訂詞律。這裏引用施蟄存先生的觀點，決不是說沒有必要學習詞律，而是為了說明詞律的研究必須包含詞樂的成分；聲文之美一旦分裂開來，平仄格律的研究就是紙上談兵。清代浙西詞派朱彝尊、厲鶚標舉雅正，必然要尋求聲文之美的合浦珠還，否則甚麼「音律嫻雅」、「曲調流美」就統統成了欺人之談。康熙末年參與編纂《欽定詞譜》的樓儼(敬思)在《洗硯齋集》也屢屢慨嘆詞樂失傳。如在《書姜夔〈暗香〉詞後》一文中，樓敬思說：

6　〈施蟄存論作詞和詞律〉，載《詞學》第 18 輯，2007 年 12 月。
7　同註 6。

一種定式。所以到今天，絕大多數宋詞只有文字留下，唱法已經失傳。本來，作為一種音樂體裁，詞的格律是為歌唱服務的；詞樂失傳之後，所填之詞無聲可倚，聲文之美無復舊觀，詞律也就成了「無源之水，無本之木」。然而，失去音樂的靈魂，只剩下文字骨骸的詞在後世，尤其是清代和民國時期，反為文人競相推崇，人人奢談填詞曲調之流美、音韻之鏗鏘，詞律成為填詞的金科玉律。如果說因為漢語本身是一種聲調語言，根據詞譜填出來的詞「音韻鏗鏘」還勉強說得過去，「曲調流美」就是十足的謊言了。通達的文學家看得出「脫離音樂，追求詞律」是虛妄的空談。比如施蟄存先生就認為：

詞律不必鑽研，至現代更沒有意義了。一切文學體式起源於民間，原來沒有格律，到文人手裏就會有格律。有了格律，民間就不受束縛，再創造更自由的體式。唐代有律詩，而後民間有曲子詞。宋詞有了格律，民間就又產生了南戲和北雜劇，這些都是明顯的例子。不過詞在宋人，格律還不嚴格，萬樹《詞律》所斤斤較量的「又一體」，其實是多一個襯字或減少一個襯字，宋人並不以為是兩個體式。有些詞中的「衍

5 當然各地還有一種普遍的吟誦辦法，但是這種吟誦界乎於念、唱之間，接近語言音調，受口語、方言影響，富即興變化，節奏自由，無拘無束，與宋代的詞牌無關。

宋韻遺珍

七七

成員的批校，嘗試解答以上問題。

宋詞的聲文之美

詞原本是一種音樂體裁，是一種歌曲形式。今天我們當文學作品來欣賞的所謂宋詞，本來是宋代的歌詞，在當時都是用來唱的。因為絕大部分曲調，也就是詞牌，在當時廣為流傳，每個詞牌都有自己固定的旋律節奏，所以文人如果根據已有的曲調來寫歌詞，或者說來「倚聲填詞」，就沒必要記下樂譜，只寫上詞牌名就可以了。歌唱的時候就按照這個詞牌的旋律節奏來唱。細心的，還註出該曲的宮調。

宋代晚期，詞這種音樂體裁逐步提高昇華，但是「曲彌高，和彌寡」，宋代之後，詞在社會上廣泛流傳的地位，就逐漸被南戲和雜劇所替代。詞本身也由歌曲變為文人案頭純粹的文學創作。相應地，脫離曲唱之後，詞牌就降格為文字、音韻結構的一種定式，或者說詞律的

態有生動的描述。4

張文虎《校勘記》「據其所知，改所不知」的斠律雖然無法完全自圓其

説，但清末的詞壇遺老，除了曹元忠説了句「竊謂以言樂律是也，若以繩白石則似不盡然」的

公道話以外，大抵還是看不太明白。但張文虎「鹽獸子」的指控，對遺老們敏感的神經畢竟

發生了作用，其後吳昌綬、鄭文焯，率皆推重張本，朱孝臧校刻《彊村叢書》亦云：「以校二

刻，互為異同，且有與二刻竝歧者。大抵張之失在字畫小訛，尚足存舊文資異證；陸則並卷

移篇，部居失次，大非陶抄六卷之舊。」

陸鍾輝刻本《白石道人歌曲》到底是不是「鹽獸子」附庸風雅的產物？果如是，陸本問世

之後，何以能震動詞壇？本文先分析宋詞的聲文之美，再考究聲文之美碩果僅存的範例《白

石道人歌曲》在清代重現的情形，特別是新發現的《白石道人歌曲》維揚馬氏底本中韓江吟社

4　李斗《揚州畫舫錄》乾隆六十年自然盦刻本卷六：「初，揚州鹽務競尚奢麗，一婚嫁喪葬，堂室飲食，衣服輿馬，動

輒費數十萬。有某姓者，每食，庖人備席十數類。臨食時，夫婦並坐堂上，侍者抬席置於前，自茶麵葷素等色，凡

不食者搖其頤，侍者審色則更易其他類。或好馬，蓄馬數百，每馬日費數十金，朝自內出城，暮自城外入，五花燦

著，觀者目炫。或好蘭，自門以至於內室，置蘭殆遍。或以木作裸體婦人，動以機關，置諸齋閣，往往座客為之驚

避。其先，以安綠村為最盛。其後起之家，更有足異者。有欲以萬金一時費去者，門下客以金盡買金箔，載至金山

塔上，向風颺之，頃刻而散，不可收復。又有三千金，盡買蘇州不倒翁，流於水中，波為之塞。有

喜美者，自司閽以至竈婢，皆選十數齡清秀之輩。或反之而極盡用奇醜者，自鏡之以為不稱，毀其面以醬敷之，暴

於日中。有好大者，以銅為溺器，高五六尺，夜欲溺，起就之。一時爭奇鬥異，不可勝記。」

詞學史和音樂史上如此重要的事件，我們卻知之甚少，所了解的背景也僅僅局限於陸鍾輝為重刻本所做的一篇短序。到了同治元年（一八六二年）夏，以「擅長樂律」而名噪一時的張文虎對比乾隆十四年（一七四九年）後出的《白石道人歌曲》張奕樞刻本，撰成《校勘記》一卷刊入《舒藝室餘筆》。《校勘記》批判陸刻，不僅說它「譜式以意改竄，每失故步」，又將先出的陸刻故意排在張刻之後，說是「同時又有揚州鉅商陸鍾徽刻本，亦云出自樓敬思，大略相同。」從表面上看，張文虎送給陸鍾輝一頂「揚州鉅商」的帽子，實際上是通過貶低陸鍾輝來排斥陸刻本，宣揚他「合各本校之，覺總不如張刻之善」的論調。在同治初年，人們聽到「揚州鉅商」到底能引發甚麼聯想呢？十八世紀寄居揚州的兩淮鹽商通常被稱為「鹽獃子」，3用今天的話說，就是「暴發戶」。《揚州畫舫錄》對其「競尚奢麗」、「爭奇鬥異」的畸形生活形

3 如吳敬梓《儒林外史》嘉慶八年鐫臥閒草堂本第二十八回〈季葦蕭揚州入贅，蕭金鉉白下選書〉：「辛先生道：『揚州這些有錢的鹽獃子，其實可惡！就如河下興盛旂馮家，他有十幾萬銀子。他從徽州請了我出來，住了半年，我說：『你要為我說的情，就一總送我二三千銀子。』他竟一毛不拔！』」又同回：「季葦蕭走了出來，笑說道：『你們在這裏講鹽獃子的故事？我近日聽見說，揚州是「六精」。』辛東之道：『是「五精」罷了，那裏「六精」？』季葦蕭道：『是「六精」的很！我說與你聽！他轎裏是坐的債精，抬轎的是牛精，看門的是謊精，家裏藏着的是妖精，這是「五精」了。而今時作，這些鹽商頭上戴的是方巾，中間定是一個水晶結子，合起來是「六精」。』說罷，一齊笑了。」

聲文之美的合浦珠還——

南宋《白石道人歌曲》在清代的重現 1

楊元錚

考究《白石道人歌曲》，是中國音樂史研究中的顯學。然而，該書自南宋嘉泰二年（一二〇二年）雲間錢希武刊行後，五百多年來始終寂寂無聞。為學者所矚目，是清乾隆八年（一七四三年）陸鍾輝在揚州重刊之後的事情。在陸刻本問世以來的這二百七十多年間，吳穎芳、戴長庚、張文虎、陳蘭甫、鄭大鶴、John Levis、唐立庵、夏瞿禪、楊蔭瀏、丘瓊蓀、Laurence Picken、鄭孟津、饒宗頤、卞趙如蘭等為《白石道人歌曲》中所保存的詞調樂譜十七闋競相著書立說，相互砥礪，其中Picken及楊蔭瀏兩家譯譜，尤且宣諸唇吻，被之管弦。2 可見，陸氏揚州重刊為關係《白石道人歌曲》八百年間隱顯的分水嶺，也是影響清代詞學指歸的一大關鍵。

1 本項研究得到香港大學Seed Funding Programme for Basic Research (201203159004)的資助。

2 Laurence Picken 譯譜擬唱的錄音，收入拙著《白石道人歌曲補箋》，即將出版。

當時文學史展開的動機。但是，由於《四庫全書》的編纂，唐宋這兩個時代的文獻都已經差不多整理完了，這時候想再發展又不能夠像浙西詞派以往那樣做了。浙西詞派整理的材料大都是以往沒見過的，可是現在，常州詞派他們面臨的時代詞籍材料都整理得差不多了，只能從怎樣闡釋去入手。而怎樣闡釋要跟時代接合在一起。他們的時代是一個憂患的時代，就是近代，跟外國有關係，碰到列強對中國的侵略。所以常州詞派是採取對原有文獻進行再闡釋，來建構他們的詞學論述的。

這兩篇作品《暗香》、《疏影》，不僅在音樂文學上有重要的地位，在文學史的發展上，也都很有意義。希望能夠以小見大，可以從這個角度切入去看文學史發展。

樣大的名聲。

擴闊文學討論空間

　　最後我們來總結一下。因為浙西詞派建構詞風，主要是發掘了很多詞學文獻。他們大力表彰姜夔，他那些很新鮮的東西對當時的讀者的確有一新耳目的作用，也能夠提供一個典型的創作範例。當朱彝尊建構浙西詞派發展的統序，他就把姜夔作為主要的人物。浙西就是浙江西部，包括杭州、嘉興一帶，但是姜夔不是這一帶的人，姜夔是江西人。他建構浙西詞派，卻把姜夔作為領袖，當然要有個說明，說明自己的動機，他認為姜夔出來以後才有很多人去追隨，所以他把以往的文學史料重新組合，來構成自己理論展開的邏輯。這邊有一段：

　　鄱陽姜夔出，句琢字煉，歸於醇雅，於是史達祖、高觀國羽翼之，張輯、吳文英師之於前，趙以夫、蔣捷、周密、陳允衡、王沂孫、張炎、張蕭效之於後。

　　「鄱陽姜夔出」，然後誰作為他的羽翼，誰在後面效法他，形成了非常嚴格的系統。這是

王昭君跟梅花放在一起。為甚麼呢？因為在邊塞是沒有梅花的，或者是梅花很少很少。因為梅花往往都是在江南，所以在很冷的地方倒不一定有梅花。元朝的軍隊打入臨安，把南宋滅了，把皇宮佔領了。當時有一個詩人汪元量就寫了一句詩，描寫南宋非常慘痛的一幕，他說這些兵「手指紅梅作杏花」，因為他們不認識梅花。以很小的事情來寫出當時那些亡國的遺民心裏是非常悲痛的。可見，用王昭君來比喻梅花確實是一個很新鮮的比喻手法。但是王昭君跟梅花也不是沒有可以相溝通的地方。因為王昭君是一個很清高的人，由於她不去賄賂畫師，所以被畫得很醜，她就沒有得到皇帝的欣賞。從清高這一點，她跟梅花能夠結合在一起；從她身世比較清寒這一點，她跟梅花也能結合在一起，所以浙西詞派認為王昭君跟梅花結合在一起，那是一種很有創造性的比喻手法，他們還是從手法上說的。

但是從常州詞派看，王昭君就不僅僅是手法，她還跟外國有關係，把王昭君跟少數民族匈奴放到一起，這個就可以跟南宋特定的時代、特定的南北關係，又能夠編織在一起。所以我說這兩首詞的解讀空間很大。因為姜夔在這兩首詞中所用的意象，很多都是借用法。他借用一種特定的手法，是別人沒用過的，或是別人用過的他重新拿來用，但是賦予了新的解讀角度。總而言之，在這一方面，做的比較新穎，使這兩篇作品的解讀空間大了，不論是浙西詞派或是常州詞派，都可以有自己的闡釋角度。所以為甚麼一直到現在這兩篇作品還是有這

影》也當作他們的經典了，這是一個非常有趣的現象。

　　當前一個流派的話語系統非常強大的時候，後面的流派應該怎樣去處理？他們的處理方式往往是並不完全迴避，除非你有非常強大的理由說他們是錯的。我們看到常州詞派在這方面並不去批評浙西詞派。浙西詞派說要怎樣開頭、怎樣結尾、中間怎麼過渡，這些東西常州詞派完全不提。他說我從另外一個方面來提問題，我提的問題就是關於寄託的問題。這就是一個接受的策略。當前面已經出現一個經典的時候，我給你的經典補充了一個新的角度或調節出一個新的角度，使得整個社會話語的系統都轉到我這邊來。直到現在，很多學者還是按照常州詞派的接受方式，就是看到由於作品裏講到王昭君，就認為很可能跟當時北宋皇朝滅亡有關係。其實要是按照浙西詞派的解釋就不同了。一開始的時候我們就用了浙西詞派許昂霄的解釋：

　　「昭君不慣胡沙遠」四句，能轉《法華》，不為《法華》所轉。宋人詠梅，例以弄玉、太真為比，不若以明妃擬之尤有情致也。

　　以上說到用「王昭君」是一個特別的寫作手法，這個比喻跟別人不一樣。雖然唐詩裏已經開始有用王昭君來比喻梅花了，因為我們知道花跟女子之間的關係非常密切；但是很難把

宋的時候才開始比較受人注意。但是由於宋代的人對詞的觀念還不是那麼崇高，在這種情況下，雖然已經開始寫詠物詞了，但還沒有發展起來，這正好在清朝可以大大發展。所以它怎樣寫、寫甚麼，就有好多人去探索。姜夔的《暗香》、《疏影》正好給了人們一個啟發。梅花人

人都寫，為甚麼姜夔寫的跟別人不一樣？

這樣，我們可以看得很清楚，在浙西詞派的系統裏，認識《暗香》、《疏影》是為整體認識姜夔這一個動機服務。整體上認識姜夔，那就超越了元朝和明朝的詞比較衰落。尤其是明朝，大家都喜歡《草堂詩餘》，而《草堂詩餘》裏一點都沒有收姜夔的東西，所以到了清代初年，他們把姜夔提出來，實際的意思是說我們可以直接把詞推到南宋，中間就超越了元朝和明朝。這樣就表達出他們要在詞的領域裏，出現一個復興。

那麼常州詞派為甚麼也把《暗香》、《疏影》作為自己的經典呢？這是最有意思的事情。

一般來說，每一個不同的流派都會尋找自己的經典，不同的流派所選擇的詞人往往是不一樣的，所以他們有區別。可是，我們看到，雖然這兩個流派事實上是有區別的，但是他們在選擇作品的時候，對於姜夔的《暗香》、《疏影》都很喜歡。為甚麼常州詞派也追隨浙西詞派的腳步走？常州詞派的建立是由於不滿浙西詞派，可是現在呢，常州詞派卻把《暗香》、《疏

當中其實也有很荒唐的地方。至少有一個地方，就是張惠言說「石湖蓋有隱遁之志」，而姜夔他說自己現在很老了，沒有能力，所以希望范成大不要隱居，還是出來做一番事業。但是現在我們都很清楚了，范成大差不多比姜夔要大三十歲。姜夔說自己老了，沒有能力了，所以把希望寄託在范成大身上，這肯定說反了。可以肯定，張惠言在寫這一篇的時候，其實沒有一個非常明確的時間概念。但是沒關係，他其實並不刻意追求歷史的事實，關鍵問題是他要讓大家知道姜夔寫這個作品是有一個特定的含意，跟當時的時代有關。而他這種看法，也是被後來的許多人繼承了。這就給我們提供一個非常有趣的思考方向。

兩派同認姜作為經典

那麼浙西詞派和常州詞派，為甚麼有這樣的不同？

張炎在《詞源》中對姜夔的肯定，主要是從詠物詞着眼。為甚麼在清代初年，有一本很重要的詞集叫《樂府補題》重新問世了，而《樂府補題》裏的作品都是詠物詞。在北宋的時候，詠物詞的創作意識還不夠鮮明。一直到南

此花幽獨」，後闋之「還教一片隨波去，又卻怨、玉龍哀曲」……乃為北庭後宮言之。

鄧廷楨《雙硯齋詞話》

南渡之後，國勢日非，白石目擊心傷，多於詞中寄慨，不獨《暗香》、《疏影》二章發二帝之幽憤，傷在位之無人也。特感慨全在虛處，無跡可尋，人自不察耳。

陳廷焯《白雨齋詞話》卷二

宋翔鳳說《暗香》、《疏影》是「恨偏安」。「恨偏安」的意思就是南宋那些君臣只知道在小天地裏偷安享樂，不知道要打到北方。蔣敦復說「暗指南北議和事」，就是北方金人和南宋之間議和的事情。鄧廷楨說「為北庭後宮言之」，這是甚麼意思呢？我們知道一個皇朝滅亡，勝利者要搶走那個被滅亡的皇朝皇宮裏的很多東西，當中包括宮女。為甚麼他說「北庭後宮」？是因為《疏影》裏出現了王昭君，而王昭君我們都知道她的故事。她是漢朝人，在漢元帝的時候被送到匈奴去和親。王昭君又是一個宮女的身分。所以說「昭君」這一句肯定是跟「北庭後宮」，就是北宋被帶到北方的那些宮女有關。陳廷焯的《白雨齋詞話》也說是「二帝之幽憤」，也就是北宋的兩個皇帝，跟北方有關。

總而言之，從張惠言開始，一直到常州詞派中好多的人都是這樣，說這兩篇詞中有寄託。

說自己以往希望在當今的社會裏做一番事業，但現在已經老了，沒有這個能力了，就把這番心願寄託在范成大身上。《疏影》「更以二帝之憤發之」，「二帝」就是北宋兩個皇帝，被金人抓到北方去了，所以在《疏影》裏，張惠言認為也寄託了對北宋的滅亡心中特別的悲憤，所以有「昭君」之句。浙西詞派是從作品的寫法着眼，常州詞派則是從作品的內容着眼，所以我說他開創了接受史的新的篇章，完全跟浙西詞派不一樣。

張惠言這麼說了以後，後來很多人都接着這麼說，下面我引的，大致都跟常州詞派有關：

句中複有白石道人也。

白石石湖詠梅，暗指南北議和事。

——宋翔鳳《樂府餘論》

《暗香》、《疏影》，恨偏安也。蓋意愈切則辭愈微，屈宋之心，誰能見之，乃長短

——蔣敦復《芬陀利室詞話》卷三

《疏影》前闋之「昭君不慣胡沙遠，但暗憶、江南江北。想佩環月下歸來，化作

維對這兩首詞沒有很正面的評價，他的觀察卻很準確。這個不斷繞圈子，寫得不是很直截了當的方式，恰恰為後來的浙西詞派創造了很大的空間。

二、常州詞派

以下看看常州詞派，他們的評價和接受跟浙西詞派不一樣。

常州詞派的代表是張惠言，最重要的是《詞選》這本書。《詞選》非常嚴格，唐五代兩宋詞很多很多，可是他只選了一百一十六篇，就在這一百一十六篇裏，也收入了《暗香》、《疏影》。可見，在常州詞派建立的時候，他們就把《暗香》、《疏影》作為一個典範。張惠言評價這兩篇作品，跟張炎的方式不一樣。他說：

此為石湖作也，時石湖蓋有隱遁之志，故作此二詞以沮之。首章言己嘗有用世之志，今老無能，但望之石湖也。此章（《疏影》）更以二帝之憤發之，故有「昭君」之句。

他說這是為范成大寫的。當時范成大想隱居，所以作這兩篇詞希望能夠阻止他，《暗香》

見了，但是《離騷》在這樣的表達方法裏體現出他那感情沒辦法控制，所以就特別展示出心理活動的複雜、豐富。在這個意義上張炎評價它就是「騷雅」，就是「清空」。

我們就不再細講《疏影》了，因為姜夔這兩首詞都是一個寫法，大都是一個側面的寫法，從不同的方面烘托、渲染、時間、空間轉換都比較大。

剛才我說到這兩首詞在文學史上很有名，但也有人不欣賞它。譬如說著名的學者王國維，他認為姜夔在整體上還是不錯的，但是對姜夔的一些作品不敢恭維，說雖然是詠梅，但一看過去沒有一句話是真正在說梅花。他是帶有貶義的。王國維基本的美學概念是不喜歡「隔」。他希望直截了當，你想說甚麼就直接說。但是姜夔他是繞着圈說的，一會兒跳到這個地方，一會兒跳到那個地方，一會兒在過去，一會兒在現在，同時他還預見未來。譬如說《暗香》的最後一句「又片片、吹盡也，幾時見得」，他說梅花落了，甚麼時候才能再看到呢？他在過去、現在、將來這三個時間中不斷轉換；而空間方面，他也是一會兒換到江邊，一會兒換到湖邊，一會兒又換到曾經跟玉人在一起摘梅花的地方。空間在不斷地換，時間也在不斷地換。他就是沒有寫梅花是多麼漂亮、梅花的形狀是甚麼樣子的、梅花的枝幹是甚麼樣子的，他都沒寫，他是讓你在人對梅花的欣賞、人和梅花之間的關係，在這樣的情境中去理解詠梅。這種寫法就是自立新意，跟當時很多很多人都不一樣。但是雖然王國

法，而這個地方他是不動聲色的，並不特別刻意。因為他跟自己的創作情景也非常吻合。他

說「何遜而今漸老，都忘卻、春風詞筆」，自己雖然忘了，花卻沒有忘，所以「竹外疏花、香

冷入瑤席」。下面仍然是說自己的感受。「江國」講的是江邊非常冷清，自己的心理狀態肯定也是冷清的。前面說到人，此

處就還要回到人。所以他就「歎寄與路遙，夜雪初積」。「歎寄與路遙，夜雪初積」，其實也

是在轉折之中。就是他感歎自己要把這個梅花寄給他思念的那個人，可是下了很多雪，沒有

辦法把花寄去。下面「翠尊易泣」，意思是翡翠造的酒杯，杯裏的酒好像淚水一樣，其實當

中暗含的也是轉折。就是想用借酒消愁的方式，但是那感情沒有辦法表達出來。「紅萼無言

耿相憶」，這個「紅萼無言」也是花在思念人。他把上、下闋之間合在一起來寫，就把不同的

結構、不同的表現手法，在同一首詞裏前後勾連得很緊。「長記曾攜手處，千樹壓、西湖寒

碧」，也是跟前面呼應起來了，他們曾經在一起賞梅嘛，我們都知道在西湖旁邊梅花非常多，

可是現在梅花全落了，就是從繁榮的時候寫到衰落的時候，它一層一層地不斷轉，也就是不

斷變化。它的不斷變化，在張炎看來這就是「清空」，同時呢，張炎還提出所謂的「騷雅」，就

像《離騷》那樣的雅。為甚麼會有「騷雅」的概念呢？大家如果讀過《離騷》，就會知道《離騷》

的描寫，也是不斷在變，而且也有一定的重複。我們讀《離騷》，看到當中有一個美人的形象

不斷出現，一會兒在這個地方出現，一會兒在那個地方出現，所以以前有人評價《離騷》，說

它東一句，西一句，有時候沒有章法，你不知道這一句為甚麼來了，那一句為甚麼突然又不

「舊時月色，算幾番照我，梅邊吹笛」，是寫過去曾經多少次在月光下一邊吹着笛子，一邊欣賞梅花。其實他是想寫現在的事情，但是過去跟現在之間是互相溝通的。這樣寫看起來就不會顯得那麼拘謹。許昂霄評價這樣的寫法就是「倒裝」。然後「喚起玉人，不管清寒與攀摘」，梅花的「寒」和天氣的「清寒」合在一起來寫，這個是過去的一種情景。然後，就不斷有所變化。他前面說自己非常懷念以往跟「玉人」在一起賞梅，下面就馬上說自己現在已經老了，用「何遜」來比喻自己：「都忘卻、春風詞筆」，再也寫不出像以往那麼美好的作品了。這是對過去的一個轉折。可是下面又轉：「但怪得、竹外疏花，香冷入瑤席」。現在都忘掉怎麼寫梅花了，好像也已經忘記了過去種種的感情，可是花並沒有忘。這樣的寫法是從北宋周邦彥那裏過來的。

描寫花的作品，在中國太多了。落花聯繫到春天的消失，又往往聯繫到自己生命不斷的消失，這是中國很多很多的作品都喜歡做的；但是怎麼寫，還是不一樣的。周邦彥有一篇很有名的詞，寫薔薇花的，他說自己在花園裏走，他非常非常惋惜花已經落去，可是他描寫的方式，卻寫花捨不得離開人，這就把整個情景更加豐富了，而且也把好像是沒有生命的自然物體，賦予了更加形象的東西。

在文學發展史上，大家都認為姜夔是周邦彥最好的繼承者。姜夔發展了周邦彥的很多手

事先寫出來。你本來是想寫現在的心情，但是先把以前的事寫出來，就是把現在、過去、將來這三者怎樣的方式加以融合，結合在一起。「借用」的意思是，同樣的意思別人用了某種特別的手法表達，你借過來用。「翻案」的意思是，別人是這樣用的，你偏偏是另外一個用法。譬如說「莫似春風」三句，一般來講，「春風」跟「梅花」之間的關係非常密切，但在《疏影》這一篇裏，就故意讓春風和梅花的聯繫不是那麼密切，所以這是「翻案」。

這麼長的一段，帶給我們甚麼感覺？他基本上都是在談創作的方法。從《暗香》、《疏影》這兩首詞裏，我們獲得最大的教益，就是在創作的方法上。如果按照這個方法去創作，那就能達到前面所說的「清空」、「騷雅」。

現在以《暗香》為例：

舊時月色，算幾番照我，梅邊吹笛。喚起玉人，不管清寒與攀摘。何遜而今漸老，都忘卻、春風詞筆。但怪得、竹外疏花，香冷入瑤席。　　江國，正寂寂。歎寄與路遙，夜雪初積。翠尊易泣，紅萼無言耿相憶。長記曾攜手處，千樹壓、西湖寒碧。又片片、吹盡也，幾時見得。

「昭君不慣胡沙遠」四句，能轉《法華》，不為《法華》所轉。

這一句實際上是用了佛教裏的典故，意思是說他能夠用自己的理解去解讀這樣的作品，而不是說必然被原來的意思牽着走。而下面就說到了用典：

宋人詠梅，例以弄玉、太真為比，不若以明妃擬之尤有情致也。……「還教一片隨波去」二句，用筆如龍。「但暗憶江南江北」，借用法。「莫似春風」三句，翻案法。

宋代人詠梅的作品往往喜歡用弄玉、太真這樣的典故，他就說不如姜夔用明妃，就是王昭君來比擬更加有情致。「還教一片隨波去」這兩句是比喻法，「但暗憶江南江北」是借用法，「莫似春風」三句，是翻案法。所以他作總結：

作詞之法，貴倒裝，貴借用，貴翻案。讀此二闋，金鑰已盡啟矣。

他的意思是如果讀姜夔這兩首詞，你就可以得到創作的金鑰匙。有一把金鑰匙，當然比你到處去摸那道門要方便多了。也就是說你有一道門可以進去了。怎麼打開這道門呢？你可以從姜夔這兩篇詞裏體會到怎麼倒裝、怎麼借用、怎麼翻案。「倒裝」在詞裏主要是把以前的

為浙西詞派的重要理論。

朱彝尊有一本書叫《詞綜》，是浙西詞派的綱領，其中也選入了《暗香》、《疏影》，不過並沒有任何評論。我們知道中國古代很多的詞選、詩選都沒有評語，它只是將作品放到一個特定的位置上，由讀者自己去判斷到底作者是甚麼樣的心理動機。但是呢，這可以由後來的人來加以闡發。浙西派有一個後學叫許昂霄，許昂霄是這樣評價《暗香》的，他說：

「舊時月色」二句，倒裝起法。「何遜而今漸老」二句，陡轉。「但怪得竹外疏花」二句，陡落。

談到怎樣開頭，怎樣轉折，怎樣變化。然後再看：

「歎寄與路遙」三句，一層：「紅萼無言耿相憶」，又一層。「長記曾攜手處」二句，轉。「又片片吹盡也」二句，收。

評價《疏影》時說：

的人開闢了很大的空間。因為這個「意」到底是指這首詞本身的意思，還是指這首詞在藝術表現手法上能夠提供的種種解讀的可能，那是不一樣的。但是，不管從哪一條來說，從南宋末年，張炎就給了那麼高的評價，說明這兩首詞已經進入到接受的層面，就不能再忽略它。

姜夔並不是一直都受到很高的評價，尤其在元朝和明朝這兩個時代。明代非常流行《草堂詩餘》，但是在《草堂詩餘》裏，姜夔的詞一首都沒有被選中。這說明，在明朝他的知名度不是那麼高，姜夔在那個時候事實上是被排斥的。

明末清初，詞壇基本上延續着明代的詞風，一直到朱彝尊的時代，就是清代初年的時候，姜夔才真正獲得了崇高的地位。這裏我引了朱彝尊的一段話：

世人言詞，必稱北宋，然詞至南宋始極其工，至宋季始極其變。姜堯章氏最為傑出。

他認為，一般人說到詞，都稱道北宋，然而詞到了南宋才非常出色，到了宋代末年才變化得淋漓盡致，它的變化符合文學史發展的規律，而在這個過程中姜夔就最傑出。由於南宋是詞發展最重要的時期，而姜夔又是這一時期最重要的、最傑出的、最有成就的。這段就成

清代對白石的評價

清詞主要有兩個流派，一個是浙西詞派，另一個是常州詞派，這兩個詞派都喜歡這兩首詞；可是，他們對這兩首詞接受的角度是不一樣的，也就是說他們都希望能夠從這兩篇被大家都認可的作品中，找到適合自己的東西。這是非常有趣的現象。而這個接受角度的不同，又可以體現出這兩首詞本身存在的接受空間是很大的，也能夠讓我們有聯想的空間。

一、浙西詞派

我們先看一看浙西詞派對這兩首詞的評價和接受。清代初年，浙西詞派形成。浙西詞派比較推崇的是南宋的姜夔和張炎，而姜夔的地位在南宋時主要也是靠張炎來加以闡發的。張炎在《詞源》中非常讚揚姜夔，當中有好幾篇提到《暗香》、《疏影》。在〈清空〉這一條裏面說《暗香》、《疏影》「不惟清空，又且騷雅」；在〈意趣〉這一條中評價是「清空中有意趣」；在〈雜論〉那一條中評《暗香》、《疏影》，則給它做了個總結：「前無古人，後無來者，自立新意，真為絕唱」。這個評價非常高。至於是不是這樣，當然可以作不同的探討；但至少在張炎的時候，他真的覺得是「前無古人，後無來者」，沒法達到這麼高的高度了。為甚麼呢？因為他自立新意。張炎沒說這個「意」新在甚麼地方，所以這樣一種解釋、這樣一種解讀，也給後來

《暗香》、《疏影》的歷史評價與接受策略

張宏生

是次撰文我將介紹姜夔《暗香》、《疏影》的歷史評價與接受策略。這兩首詞不僅僅具有音樂的價值，同時具有文學的價值。從文學史的角度看，它的影響能夠一直從南宋延續到清朝，不僅大家都欣賞，同時還能體現出一些詞風的轉變。所以我說這兩篇作品就不僅僅是在音樂史上非常非常重要，而且在文學史上也很重要。

對《暗香》、《疏影》，相信大家都有一定的瞭解。姜夔到蘇州的石湖去拜訪范成大，在那兒住了一個多月，應范成大的邀請創作了這兩篇作品，范成大非常喜愛，後來也就慢慢傳播開來了。有一些詞人就模仿這兩篇的詞牌去寫。我們都知道，南宋的末年，中國的詞發展進入到新的時期，尤其在理論的探討方面，有很大的成就，特別是張炎，他在《詞源》裏提出一系列的理論和主張，對以後詞的發展有非常非常重要的作用，裏面也提到《暗香》和《疏影》。可是在元代和明代，它們的情況就不是那麼清楚，一直要到清代初年，才又引起詞壇的注意。

- Lam, Joseph S.C., "Writing Music Biographies of Historical East Asian Musicians: The Case of Jiang Kui", *The World of Music*, 43（1）2001, pp70-95.

- Liang, David, "The Tz'u Music of Chiang K'uei: Its Style and Compositional Strategy", *Rendition*, Nos. 11&12, Special Issue on Tz'u (Hong Kong: The Chinese University of Hong Kong, 1979), pp211-246.

- Pian, Rulan Chao, *Song Dynasty Musical Sources and Their Interpretation* (Cambridge, Mass: Harvard University Press, 1967; rep. Hong Kong: The Chinese University Press, 2003).

- Tse, Chun Yan, "From Chromaticism to Pentatonism: A Convergence of Ideology and Practice in Qin Music of the Ming and Qing Dynasties", PhD diss., CUHK, 2009.

音響資料

- 《國樂大師會萃：姜白石宋曲十八首》（琵琶：劉德海；板胡：劉明源；笛子：朱潤福；古箏：范上娥；古琴：李祥霆），1999年。

- 《紀念楊蔭瀏百年誕辰：傳承》（演唱：周靈燕），北京：中國音樂研究所，2000年。

- 《姜白石詞擬唱》（張麗真、蘇思棣、劉楚華、劉國輝）香港：香港浸會大學中文系，2004年。

- 《秋月清霜》（古琴：謝俊仁；演唱：余美麗），香港：雨果製作公司，2011年。

有問題，最重要是語言節奏能說服自己、觀眾，以及不失那個可依賴的傳統。

徐嘉欣筆錄

文字資料

- 陳應時：〈論姜白石的《側商調調弦法》〉，《音樂學叢刊》第三輯，（北京：文化部文學藝術研究院音樂研究所，1984年），頁22-42。

- 姜夔著、夏承燾校輯：《白石詩詞集》（香港：商務印書館，1961年）。

- 夏承燾：《唐宋詞論叢》（香港：中華書局，1962年）。

- 楊蔭瀏：《中國音樂史綱》（上海：萬葉書店，1953年）。

- 楊蔭瀏：《中國古代音樂史稿》（北京：人民音樂出版社，1981年）。

- 楊蔭瀏、陰法魯：《宋姜白石創作歌曲研究》（北京：音樂出版社，1957年）。

- Lam, Joseph S.C, "Chinese Music Historiography: From Yang Yinliu's A Draft History of Ancient Chinese Music to Confucian Classics", *ACMR Reports*, Vol. 8 no. 2, 1995, pp1-46.

到了八十年代《國樂大師薈萃・姜夔宋曲十八首》的CD，以純樂曲編製，不過我認為該錄

音不唱姜夔那幾首曲文，參考意義不大。

演繹的原則

簡單總結我的看法：姜夔「其人」其實除了文人的形象外還有很多不同的面相。至於今日

演唱白石詞的問題，事實上怎樣編配也可以，無所謂對錯，因為根本沒有一個延續的傳統可

以依靠；不像崑曲、琴曲各自有一個或多個延續不斷的傳統。姜夔的譜，沒有一代接一代地

流傳下來，而是在二十世紀初被重新發現的。譜上所記的音高問題不大，即使是差半音也不

能算錯，因為中國傳統的演奏可以有很大變化空間。在編製時，怎樣配一個長音也有不同方

式處理，譬如你是否會另加一個對位式或和聲的聲部呢？《姜白石詞擬唱》這個版本是比較純

樸，讓古琴和洞簫都襯托了演唱者的歌詞；如果加一些應和的樂句或拍板也不一定是壞事；

只是「加」了之後不要影響聆聽者的欣賞。即是說你可以根據你所熟悉的中國傳統音樂伴奏風

格來編配。但是，我不同意加入西方聲樂的演繹，或西方歌劇的元素。演繹哪一個版本都沒

分，今日暫且不講，全都是「心飛太行，膽落戰鼓」，充滿男性氣概的樂曲，表現了姜夔的另一面。

二、趙如蘭的版本

一九六七年，趙如蘭老師也製作了譯譜，與楊蔭瀏的譯譜作比對，可見兩者的分別，也體現了音樂學譯譜的發展。趙如蘭老師那個版本是六十年代音樂學譯譜的做法，不用小節線，因為不能用 2/4、3/4、4/4 拍子來規範姜夔的歌曲，那些強弱、次弱是沒有意思的，只能在該斷的地方稍有表示。實際上，這與楊蔭瀏早期緊跟西方小節線的做法，已有所改變了。

三、梁銘越的版本

一九七九年，梁銘越老師的版本都沒有小節線，他的演繹、節奏是參考當年葉嘉瑩教授的朗誦節奏，至於音符的時值及樂句的長短他有自己的理解；要注意的是，其小節線是虛線。為甚麼要用虛線呢？因為在西方文藝復興時期音樂的現代記譜，不會像現在的 3/4、4/4 拍那樣切實的強弱拍，故用虛線，因為當時的音樂根本沒小節這個觀念，所以用這個譯譜方法來譯姜夔的曲，我認為比較合理。

事實上，現代的姜夔研究被壓制多年，因為他是一個「封建頹廢文人、小資產階級、溫情主義者」，所以在文革時期不能唱他的曲，否則會被拘捕。不過，姜夔資料相當重要，因此楊蔭瀏和陰法魯於一九五七年出版了姜夔研究。而楊蔭瀏的《中國古代音樂史稿》雖然在一九六一年寫成，也由於文革而不能出版，礙於出版客觀條件的限制，以致文中對姜夔多有批評。以下看看楊蔭瀏在一九八一年出版的《中國古代音樂史稿》，有兩頁講述姜夔，他這樣寫道：

在內容上，想到「胡馬窺江」，不是義奮填膺，而是喪氣害怕，而且還以不能依翠恨紅，「難賦深情」為恨，是頹廢到了極點。在音樂形式上，本曲也分前後兩疊，但後疊比起前疊來，在音調有着極大的變化。作者雖然有其音樂創作天才，但其作品的內容一般都是屬於個人感傷情緒的抒發，包括着頹廢的因素。這是為其階級地位和生活範圍所決定的。

難道他不知道姜夔的重要性嗎？我認為在當時的情況，他不這樣寫便不能出版，因此他用了曲筆，可謂用心良苦。以六十年代的語言來説，姜夔在音樂上的特色不是「清空」，而是「頹廢」，而且「頹廢」得來具有極高質素。「F」到「B」的音程在《揚州慢》裏是很突出的；記得我學習姜夔的音樂時我是沒有聽過的，因此，現在有此錄音，十分有用。關於鐃歌的部

把「F」升為「F#」，變成純四度，這樣的處理在西方是可以理解的，但並不切合中國音樂的實際操作。

北京中國音樂研究所的《揚州慢》，是二〇〇〇年為了楊蔭瀏先生誕辰一百週年紀念活動所製作的。演唱者、演奏者我們都可以知道是誰，但唯獨欠缺標示編曲者。大家要注意到編曲的音樂語言與姜夔沒有關係，而歌唱者周小姐是以典型西式的專業唱法來演繹的。在我看來，這種編配跟顧嘉輝編無線電視劇沒兩樣，與姜夔《揚州慢》裏所表現的清空意趣相違。雖然已是非常專業的聲樂家、二胡、琵琶演奏家，但卻沒有跟聽眾交代這曲譜由誰人所編，以及為何這樣編。其編配可以說是濫用小調和弦的琵音（abusing minor triad），對我來說十分刺耳，跟我想像的中國感覺完全不一樣；另外，為何要加arpeggio（琶音）呢？如果這是顧嘉輝或倫永亮編的流行歌曲便沒有問題，然而用這種音樂伴奏去配姜夔的曲和旋律，則時空交錯得太那個了罷。我認為現代人怎樣編配古代的音樂這個問題很值得反思。

剛才所聽的版本是採用楊老先生的譜（即升「Fa」）。饒公沒有用簡譜和線譜，於是沒有這個問題。其實，工尺譜原具彈性，可以高半音或低半音。趙如蘭老師所編的「E♭」到「A」仍然是增四度的⋯；而梁銘越也是保持由「F」到「B」。

一、楊蔭瀏的版本

在楊蔭瀏和陰法魯一九五七年的譯譜中可見，「自胡」、「漸黃」、「算而」、「念橋」的兩個音是「F♯」到「B」，但本來是沒有「F♯」的，應該是F：「自胡」、「漸黃昏」、「算而今」也用了「F♯」；此外，「算而」那裏由「Fa」到「Ti」的上行音程，他改成了 F♯ 到 B。楊老自有其道理。且讓我討論一下他改音程的理由。

我有幸於一九八〇年在北京見過楊老先生，雖然當時我不太明白他說甚麼，但我由此了解到楊老先生是一個洋派的人。當我問及他參與編輯基督教聖詩集《普天頌讚》時，楊老用字正腔圓的英語回答我：「I am a Christian!」（我是一個基督徒！）如今我還存着這卷錄音帶呢！

他學過五線譜、風琴，所以我猜想他當時理解「自胡」兩字若是從「F」到「B」的音程，便是西方音樂所說的「tritone」，即增四度，是不中聽的音程，因此楊老把「F」變成「F♯」，使音程變為純四度（perfect fourth）。然而，這並非中國音樂本來的面貌。「F」到「B」的音程，在今天十二平分律來說是增四度，但《揚州慢》不是使用十二平分律，也不完全是西方所說的增四度。所謂增四度（augmented fourth）和減五度（diminished fifth），在西方巴格尼尼（Paganini）的年代被稱為「魔鬼的音程」，是禁止使用的，因此根據這個理解，楊蔭瀏先生

從范成大口中得知「琵琶有四曲」——《濩索・梁州》、《轉關・綠腰》、《醉吟商・胡渭州》和《曆弦・薄媚》，現已失傳，但在當時應該十分流行；而「濩索」、「轉關」、「醉吟商」、「曆弦」均與調弦有關，可能是當時的術語。姜夔記住了范成大所言，其後在辛亥之夏到金陵拜見楊廷秀時，便在楊氏的樂工手中求得《醉吟商・胡渭州》之品弦法。由此可見，他非常着意琵琶曲、古琴曲，或是舊的《霓裳羽衣曲》；當他找到後，每次都會填詞。多虧他在文學上和音樂上的關注，使當時的音樂流傳至今。

看《揚州慢》的不同譯譜

那麼現代人應怎樣看待、處理白石約九百年前的作品呢？以下先以一九五七年，楊蔭瀏、陰法魯所做的《揚州慢》譯譜作例。其實還有其他學者做過姜夔詞的「打譜」工作，如英國學者Laurence Picken、丘瓊蓀先生、鄭祖襄先生、饒宗頤先生等。事實上，在二〇〇四我們香港的古琴、崑曲專家也做了一個《姜白石詞擬唱》，我不敢說批評或比較，但希望由此帶出譯古譜的難處，以及解決怎樣面對九百年前的作品的問題。

後，又在樂工故書中得到《霓裳曲》十八闋。他看到的十八闋可能是南宋版本，未必是唐代的，但已十分難得。至於「皆虛譜無詞」，即沒歌詞的譜。事實上，《霓裳曲》十八闋原該有唱的部分，但不是每段也需要唱而已。因為是歌舞樂，有些沒填詞也是合理的。只因姜夔是詞人，所以他根據自己的喜好把古譜填上詞。轉角度看，假設沒有填上詞便不會流傳至今了。

琵琶四曲

　　簡單總結這三種不同的古譜，即在《越九歌》所用的律呂譜、在《古怨》所用的古琴減字譜，以及第三種是宋代早年以俗字記錄的工尺譜。姜夔很多首詞的序，如《角招》、《徵招》、《淒涼犯》都是宋代重要的樂理資料。以下再舉一例，《醉吟商小品》序中可見：

　　石湖老人謂予云：琵琶有四曲，今不傳矣，曰濩索（一曰濩弦）梁州、轉關綠腰、醉吟商湖渭州、曆弦薄媚也。予每念之。辛亥之夏，予謁楊廷秀丈於金陵邸中，遇琵琶工解作醉吟商胡渭州，因求得品弦法，譯成此譜，實雙聲耳。

行業亦一樣，他們知道你不會明白，於是不願浪費時間跟你分享經驗和樂譜的。因此，姜夔能跟樂工交流、覺得古譜，代表他有不錯的音樂造詣。

另外，他不只在一首詞的序裏提到某一兩首傳統古曲才會用特別的調弦）弦法（今日的琵琶除演奏某一兩首傳統古曲才會用特別的調弦）不只有一個品弦法，而是有很多種品弦法任由作曲家及演奏者選擇。如果一個音樂家或填詞人，關心到這些細節，我認為他真是行家。

此外，幸好姜夔有尋古譜的喜好，今天才有宋代的珍貴音樂資料流傳，《霓裳曲》便是一例。假如他在《霓裳中序》所說的是事實，那表示我們保存着一首由宋代流傳下來的唐代樂曲。可惜他沒有為整首《霓裳曲》填詞，以致現在我們對唐代樂曲《霓裳羽衣》的討論，只可依賴白居易的《霓裳羽衣歌》，可謂紙上談兵，毫不實在。幸好他清楚記述覺得這首曲的過程，讓我們能了解當時的情況：

丙午歲，留長沙，登祝融，因得其祠神之曲，曰黃帝鹽，蘇合香。又於樂工故書中得商調霓裳曲十八闋，皆虛譜無詞。

他「登祝融」而得《黃帝鹽》、《蘇合香》兩首樂曲，這兩首曲應該是從西域傳來的；然

讀，有些人從音樂角度切入去解讀，我們把兩者不同的解讀結合起來，或可建立較完整的看法。

回到《側商調》的文本「予既得此調，因製品弦法並古怨云」，姜夔記錄品絃法，其七條弦依次稱作大、二、三、四、五、六、七，清楚指示如何調慢角調，是「宮、商、角、變徵、變宮、清商」；與一般古琴正調比較，正調是「So、La、Do、Re、Me、So、La」，但變音後是「Do、Re、Me、升Fa、La、Ti、Re」，你可以想像到兩者的調式並不一樣。以上便是我可以與各位分享有關解讀《古怨》的一些經驗。

姜夔的音樂造詣

姜夔是一位音樂學行家、實況調查者（fieldworker）。他會和樂工交流、找他們的樂譜。

事實上，如果想跟樂工拿譜是很困難的。從我自己的經驗可知，別的樂手是不會輕易跟你溝通交流的，因為大家專長、興趣未必一樣，甚至會涉及利益衝突；比方說在殯儀業裏，殯儀業工作者不會跟你分享他的專業技術，因為你懂了之後便會成為他的競爭對手；粵劇、粵曲

「變徵為散聲者曰側弄，側楚、側蜀、側商是也。側商之調久亡。」

（姜夔著、夏承燾校輯，1961年）

「其宮商角徵羽者為正弄」，即是以正聲的「宮、商、角、徵、羽」五個音作空弦音，但接着「慢角清商宮調，慢宮黃鐘調」的斷句，使我有所誤解，以為「慢角清商宮調」是一個名詞，而這個名詞等於「慢宮黃鐘調」。後來才知道錯了，發現原來琴樂中有多個調子（調弦）的名稱。其實「慢角」是一個調名，清商、宮調、慢宮、黃鐘是另外四個調的調名。我們亦可以反過來，從後面的文字來解讀前面的文字。「其宮商角徵羽者為正弄」，即是五個正聲「宮、商、角、徵、羽」作空弦音，稱為正弄；後句「加變宮、變徵為散聲者曰側弄」，「加變宮」即「Do」的低半音，「變徵」即是「Sol」的低半音，按傳統理解，這兩個變化音皆非正聲，而是側聲，而以側聲造空弦音便稱為「側弄」。這樣對讀便知道甚麼是「正弄」和「側弄」。至於「側楚，側蜀，側商是也」一句，八十年代在曾侯乙編鐘出土之時，我常在文章看到「側商調」一詞，當時我並不知道側商調是甚麼，但姜夔這段文字其實已說明「側楚，側蜀，側商」是三個側弄，表示三個不同的調。根據這個解讀，我們回到「慢角、清商、宮調、慢宮、黃鐘調是也」一句，便可知道慢角、清商、宮調、慢宮、黃鐘調是五個不同的調。後來翻閱關於琴的資料才知道這是對的。陳應時先生於1984年已經是這樣閱讀的了。簡單來說，做研究時，在不盡信前人的前提下，要懂得閱讀不同人的研究，因為有些人從文學角度切入去解

直的，是故雅樂推崇敲擊樂器，喜歡其敲打後不能變音。雅樂的美學認為變音便會感動人，不論是哀傷或喜樂的感動都是不好的，只要做到使聽者中正平和、守禮便足夠。因此，雅樂較多用鼓之類的敲擊樂器。不過，雅樂也不是完全拒絕絃樂器的，譬如以古琴、瑟等絃樂器彈奏，只要不把音高改變便可；但是若用揉絃演奏，便不是雅樂。所以雅樂中的琴、瑟並不用左手按絃，用右手撥琴絃便了，不能用左手揉絃使其音高及音色變化。

解讀《古怨》

接下來談談《古怨》，它以「減字譜」記錄。看「日暮四山兮，煙霧暗前浦」一句旁邊有古琴指法譜，一字配一個指法，一字一音，而非一字多音，是一種接近雅樂的風格。以下的一小段《側商調》用作分享我的學習經驗，我發現懂一點音樂知識能方便斷句。夏承燾先生校釋本的原文，是這樣斷句的：

琴七弦散聲，具宮商角徵羽者為正弄，慢角清商宮調，慢宮黃鐘調是也。加變宮

段之後，音色便不一樣了，其實並不合理。傳統的簫，前面的五個孔是平均孔，其音律與鋼

琴的十二平均律不協調；於是現代人為了遷就鋼琴的「Mi」到「Fa」、「Ti」到「Do」之近間的半

音，便把現代的簫和笛中的其中兩個孔造得比較接近。從這個例子可見，自魏晉隋唐以來，

胡樂進入中國之後，中國樂器的音律出現了變化：由於四處都唱胡曲、奏胡樂，唐代尤甚，

於是這些音樂影響了宮廷的音樂。再舉另一個很嚴重的例子，很多文獻提到「黃鐘調」變成

「林鐘調」的事，因為「林鐘調」能切合現代的「Do、Re、Mi、Fa、So、La、Ti、Do」的七聲音

階，然而中國傳統雅樂本是用「Do、Re、Mi、升Fa、Sol、Ti、Do」；這說明宮廷雅樂也受到外

來胡樂的影響。於是，當年那些衛道之士便提倡雅樂不應受這些影響，姜夔的《大樂議》便主

張這種看法。

雅樂的美學

　　雅樂其中一個特別之處是不推崇弦樂器，即使是管樂器都不應奏出「震音」；譬如拉二胡

和小提琴會有揉絃。所謂震音，是指將同一個音高稍作變化，使其更接近人歌唱的效果，更

有感染力。然而以音高的變化去感染聽眾恰恰跟雅樂的美學相違背。因為雅樂要求音色是平

一下「南呂」的鐘，然後可能唱五秒或更長，接着唱另一個字和轉換另一個音，毫不困難。一字一音，中正平和，相當規範化的音樂，這就是雅樂風格。如果你喜歡「RAP」或喜歡 Michael Jackson，那麼你聽雅樂便會睡着。在中國音樂史的討論中，會經常看到以下的形容：雅樂衰落、雅樂沉悶。如魏文侯：「吾端冕而聽古樂則惟恐臥，聽鄭、衛之音則不知倦」；齊宣王：「寡人非能好先王之樂也，直好世俗之樂耳」。君主多不好雅樂而好俗樂，聽雅樂會睡着。然而，這是正常的表現，不表示雅樂因此而衰落。因為每一個王朝都必需演雅樂，不會因為它沉悶而停演。比如周日彌撒唱聖詩，你不會用重金屬音樂（heavy metal）。太樂作為祭祀的音樂即雅樂，在每年特定的日子，如祭天地、先王、農桑、春秋二祭，都需要奏雅樂。每一王朝都需要演雅樂，不演即意味其滅亡，所以應該不存在雅樂衰落的問題。

外來胡樂的影響

文人每次呈上新的樂議，是因為十二律的基本音「黃鐘」不對、其他音律不準，並指出是受胡樂所影響。這說法道出了當時實際遇到的問題。譬如現代有些簫可以分作兩段，我年輕的時候以為這樣很先進，可以調音；然而分成兩它們時常說前朝禮崩樂壞，不單只有姜夔，他們時常說前朝禮崩樂壞，是因為十二律的基

認為他向朝廷進呈《大樂議》是為謀一官半職的。假如朝廷接受了，便會委派他負責這項工作。事實上，歷代文人皆如是，他們都有求取功名的抱負，獻上自己的意見是晉身的方法。可惜，朝廷接收《大樂議》後並沒有進行其音樂計劃。據《齊東野語》的姜堯章自敍所述，有兩名宰相很喜歡他的樂書，然而為甚麼不實際推行呢？自敍中有部分內容應當是他的理解，或未成事的想像。當然，也可以是呈上詩詞或意見，在討論的過程中大家都認為很好，但要具體實行時卻不考慮而已。簡單總括一下，我認為他是想求功名、找工作的人。不過假使他真的覺得一官半職，便未必能寫下那麼多、那麼高水平的詩詞了。

律呂譜顯示雅樂的規範

以下看看《越九歌》的譜，這譜收入在夏承燾先生的《白石詩詞集》。歌詞是四言的，像《詩經》一樣，但我不多作解釋了，我主要想跟大家分享這份律呂譜。大家看看「南蕤林南」，即南呂—蕤賓—林鐘—南呂，譜中清楚標示「南蕤林南」的音律對「央央帝旗」的詞，讓人知道「央」一字是唱「南呂」音。這是定音記譜法。與這種譜式有關的樂器是雅樂用的編鐘、編磬，在每個鐘及每片磬上都刻有音律的名字，而這種音樂一般並不急速，如「央」字，打

三九

·三八

而他沒有填詞的那些便失傳了。他除了把那些原本沒有歌詞的古譜填上了詞以外，還用俗字譜記錄了其旋律的音高。其中大家最熟悉的有《霓裳中序》和《醉吟商胡渭州》。請注意這兩首都不是他自製的曲，而是他找到所謂的古譜後便記錄、填詞而已。此外還有《玉梅令》，是范成大作了旋律後找他填詞的作品，都不算姜夔的自度曲。其餘的十四首自度曲才是他自創的，由於是自創的及發掘出來的古調，跟一般詞牌不同，所以他要記下旋律。這就是他要記譜的原因。

向朝廷獻《大樂議》

現在我們看看為甚麼他會寫十首《越九歌》和十四首鐃歌。從他於一一九七年向朝廷獻上的《大樂議》便可略知一二。

「大樂」解作「太樂」，是宮廷祭祀時所奏的樂章。太樂是每個王朝都會嚴肅處理的事。因為中國人有一種信念，認為太樂的音律不對或制度不好，禮崩樂壞，王朝會滅亡。直至現在，在中國，即便是形式不同，音樂和政治的關係仍然沒有改變；大家留意音樂史，知道歷朝的《樂志》、《樂書》所談的都是統治術，把音樂與政治掛鈎。《大樂議》是姜夔推銷自己音樂意見的計劃書，闡述重新制定樂器，以至音律的看法。可見，姜夔是一個熱衷功名的人。我

怕只有姜夔。第二種是**減字譜**，他的《古怨》是一首琴歌，是流傳至今唯一的宋代減字譜琴歌，具劃時代意義，但這不是如今我要談的重點。最後第三種，是大家比較熟悉的**姜夔自製曲**，或稱**自度曲**，全用當時流行的工尺譜記寫。這些在中國音樂史上稱為宋代**俗字譜**。在過去學術上研究白石詞譜，多集中在這十七首用俗字譜記寫的詞樂及其用減字譜記寫的琴歌《古怨》上。作為一位作家，或詞人，或音樂家，竟用了三種不同的樂譜記錄；在音樂史上，極不尋常，以古譜學的角度而言，當然十分重要及珍貴。光是這一點，姜白石已夠可愛的了，很值得我們推崇。

喜尋古譜

　　另外，他還有一個特別的喜好。他跟中國文人一樣，都好古。他的品味以（他想像中的）「古代音樂」為依歸。日常生活中，他除了吹簫、跟小紅唱曲外，更遊遍湖北、湖南、江西等地，他喜歡到當地的廟宇尋覓古譜、跟樂工聊天。我相信一般詞人懂得填詞便足夠，對於甚麼是「琵琶調弦法」或「古琴品弦法」，不會深入研究，這些絕對是音樂行家才會關心的問題。

　　由於他對古樂、古譜的着意，他把在當時（南宋）收集到的一些古譜填了詞。當中或可能有造假，我還沒有深入研究，也不敢確定。若他沒有作假，那些古譜便因為他才得以流傳，

可能當時還有其他人記下了樂譜，但由於名氣不及姜白石，於是便失傳了。

三種譜式的記錄法

更難得的是，以古譜學的角度而言，姜夔一人所流傳的音樂資料便有三種不同的譜式：

讀文學的都理解寫詩填詞的時候，一般不會記下工尺譜或律呂譜，因為吟唱的時候直接便唱，同時不同地方所唱的詩詞都有其調子，傳統流傳下來便自然懂得，不用記譜。譬如我們出席天主教彌撒所唱的聖歌，甚至國歌，都可以直接自記憶唱出來。同樣道理，大家熟悉的宋代詞牌，填《鷓鴣天》、《菩薩蠻》便不用寫樂譜，因為都在記憶中。那為甚麼姜夔要記下他的詞譜呢？因為他記下的是他新創作或當時人不熟習的旋律，當時人不會認識他製譜（創作）的那十七首曲子詞和琴歌《古怨》的曲調，若不記下樂譜便無人懂得唱。於是極珍貴的宋代音樂資料便得以流傳下來。

第一種是《越九歌》所用的**律呂譜**。以律呂作記錄，以第一個字來標示，如「黃」、「大」，分別代表「黃鐘」、「大呂」，相當於現代的「letter Name」，即「ABCDEFG」，只要知道方法，任何人都能懂。宮廷雅樂用律呂譜的譜式記錄，而民間個人用這種譜式記寫自己作品的，恐

至於距離宋代有多近或有多遠，則僅能與各位分享一些個人粗淺的體會。

姜夔是行家，能彈琴，又懂吹簫。當我們看古代文獻，發現中國文人用文字表達音樂時寫得天花亂墜，但可看出有些文人是不懂音樂的，因為如果懂得音樂便不會那樣斷句或解讀。不過，要既懂文學，又懂音樂是有難度的；同樣，我們這些讀音樂的人對古文的解讀亦有一定難度；姜夔卻很特別。

先說《越九歌》，這是一套用雅樂風格創作的音樂。姜夔模仿屈原《九歌》這個古老的形式，以四言創作，寫了十首，而且還用律呂譜記下了旋律，是有意識的創作。另外，他還作了十四首「鐃歌」。鐃歌即軍樂，那應是雄赳赳、氣昂昂，戰場上用的音樂。無論是雅樂還是軍樂，當中所表現的跟姜白石在文學上標榜「清空」及「小紅低唱我吹簫」的形象完全不同。我認為做研究要從整體觀察，像這十四首鐃歌沒有曲譜流傳，文學上或有研究，但研究音樂的學者卻沒有注意。

在音樂的角度來說，姜夔的音樂資料非常重要。我們現代人老是以為中國音樂沒有樂譜流傳，因為古代不用五線譜、簡譜。而中國民間通用的工尺譜，多是明、清兩代的資料；唐、宋、元幾代的資料實在不多。幸虧有姜夔，因他的名氣大，宋代的樂譜資料遂得以流傳。

嗟夫四海之內知己者不為少矣，而未有能振之於窶困無聊之地者。舊所依倚，惟有張兄平甫。其人甚賢，十年相處，情甚骨肉，而某亦竭誠盡力，憂樂關念。平甫念其困躓場屋，至欲輸資以拜爵。某辭謝不願，又欲割錫山之膏腴，以養其山林無用之身。惜乎平甫下世，今惘惘然若有所失！人生百年有幾？賓主如某與平甫復有幾？撫事感慨，不能為懷。平甫既歿，稚子甚幼，入其門，則必為之悽然。終日獨坐。逡巡而歸，思欲捨去，則念平甫垂絕之言，何忍言去？留而不去，則既無主人矣！其能久乎？

他的名氣很大，但唯一的遺憾是沒有功名。他感謝張平甫對他的提攜及照顧。當時張平甫為他捐官，姜夔推辭了；他不做官，張平甫「又欲割錫山之膏腴，以養其山林無用之身」，分地、買房舍給他；可見二人交情如骨肉至親，因此我相信姜夔在某程度上是衣食無憂的。

音樂行家

他在當時的文藝圈子很受歡迎，但我所關注的是音樂方面。我沒資格說他的詩詞，但他真的是音樂行家，絕非冒充。他懂得製曲。所謂「製曲」是寫旋律的意思。二十世紀重構宋代音樂的成果，即是用現代人的解讀與唱奏方法去演譯宋代的曲譜，各家各派的研究深淺不一。

有意思，甚具啟發性。他主要引用了周密《齊東野語》所收錄的〈姜堯章自敍〉。

《齊東野語》所載的姜堯章（姜夔）自敍帶來不少的訊息，跟我們從白石詩詞裏面所讀到的姜夔頗有出入，並非大家所熟悉的概念，如「清空」的種種感覺。我覺得這個姜夔有點像今日的推銷員，不斷地炫耀自己的文章、詩詞及書法如何為時人所稱頌。文中說：

名公巨儒，皆嘗受其知矣。內翰梁公，於某為鄉曲，愛其詩似唐人，謂長短句妙天下。樞使鄭公受口文，使坐上為之，因擊節稱賞。參政范公以為翰墨人品，皆似晉、宋之雅士。待制楊公以為于文無所不工，甚似陸天隨，於是為忘年友。復州蕭公，世所謂千岩先生者也，以為四十年作詩，始得此友。稼軒辛公，深服其長短句……皆當世俊士，不可悉數，或愛其人，或愛其詩，或愛其文，或愛其字，或折節交之。

可見姜夔是多麼討人喜歡，自敍筆下的姜夔就像香港的張國榮。後面那一段講述姜夔和張平甫的關係，平甫歿後更念及其稚子，流露出濃烈的感情，比較像我們從詩詞中認識的姜白石：

重訪白石其人及其音樂資料　余少華

　　首先很感謝劉楚華老師給我這份把「文學」和「音樂」放在一起的功課。嚴格來說我沒有真正研究過姜白石，這次「重訪」白石，是把過去讀過的、已經丟下了二、三十年的資料整理一下。在香港，音樂系雖然有中國音樂史一科，但在當今中國音樂的領域中，姜夔課題的研究可能慢慢會被現代學術路向擠到「無立足」之地了。所以今天我感受良多。

　　以下我想從音樂的角度，跟大家分享我對姜夔詞譜這問題的看法，嘗試重訪白石其人及其音樂資料。現在先說「其人」。談姜夔其人，我們不可以孤立地看，必須連同他的音樂一起述說。

　　大家讀姜夔詩詞，對他的生平都會很熟悉，其實我們對姜夔的理解似乎還流於片面。美國密歇根安娜堡分校 (University of Michigan at Ann Arbor) 的林萃青教授，在其有關音樂傳記的文章中，用了西方新近流行的方法討論音樂家傳記的問題 (Lam, 2001)，我覺得他那篇文章很

二

——

探
索
篇

錄音隨筆

祈道緯

此次錄音的最終目標，是儘量獲得聽眾現場聆聽演奏的效果。這涉及到空間的維度，與場地的音響特點。只有在適合的空間，每件樂器的音色才能非常清晰，樂音才能混合得非常自然。為此，我們同時採用近距離拾音與環境拾音技術，同時使用數位設備與類比設備。

由於古琴音色豐富，錄音也就極具挑戰性。為了記錄古琴的音色，我們使用了三個麥克風：一個懸於右手側，一個位於左手側，另一個置於古琴底部與琴桌之間，以便抓住古琴低沉的音質。

「縱」字，自然地用六絃七二、三間，以和應歌者激動的情感。

虛實處理。白石詞風格清空，擬訂琴譜時，尤其不敢隨意加添音節，只偶然增加虛音變化，如猱、吟、進復、虛罨。如《揚州慢》：「波心蕩，冷月無聲。」句讀處的按音不作吟猱，留白以配合停聲待拍的效果。另外，《揚州慢》曲終也以按音不動作結；又《鬲溪梅令》及《角招》末句則試用二四絃輕撮（即西樂大四度），意圖達到似完未結、意猶未盡的感覺。

撫琴石林中

鍾兆燊

有幸參與白石詞唱重構中的琴樂部分，摯誠感激幾位老師處處包涵接納，又得多位學者不吝賜教，解決了許多問題，迴避了配器思維之弊。謹誌古琴伴奏訂譜情況大略如下：

以詞應聲。這次白石詞重構，古琴指法安排，首在體會文詞意思，其次留意指法順暢。如《揚州慢》：「淮左名都，竹西佳處」起首二句，用泛音、散撮，在營造氣氛；及後「清角吹寒，都在空城」等句，都以按音處理。為了配合歌曲聲調的走勢，唱腔暗折處多用進復、退復或分開；配合字聲，「木」、「月」、「綠」等入聲字用伏絃；上聲、去聲如「賞」、「念」等，則用綽、注或虛上等指法。

取音不拘成法。白石詞樂用七聲。我嘗試隨勻孔簫笛取音，其中「凡（正弄）」音，即不按七絃八半而用六絃七四，「乙」音則較平均律稍低。此外，演奏時我會緊隨歌者實際表現當下調節。如《揚州慢》中：「杜郎俊賞」的「俊」字，按七絃七九取音，下句「縱豆蔻詞工」中

定調表註：

1 「姜白石自度曲」伴奏樂器使用張設絲絃之古琴及低音琴簫，定音較低，錄音時音高比原擬笛色約低三至四律。

2 《杏花天影》原譜未有注明宮調，依夏承燾先生定為中呂調。

3 各家譯譜定調互有歧異，上表各曲上音音高，楊蔭瀏定為 F，F，F，D，C，C，C，A，A；丘瓊蓀則定為 ♭A，B，B，F，A，♯F，♭E，G，♭B。

姜白石自度曲十首定調表

自度曲	原譜 定調	宋韻遺珍				錄音演奏 音高
		笛色	簫 筒音	古琴 調絃	古琴 一至七絃定音	
鬲溪梅令	仙呂調	正宮	合	正調	合四上尺工六五	上音 ≒ ♭E
暗香	仙呂宮	正宮	合	緊五	合四上尺凡六五	上音 ≒ ♭E
疏影	仙呂宮	正宮	合	緊五	同右	上音 ≒ ♭E
淡黃柳	正平調近	小工	上	正調	上尺凡六五仕伬	上音 ≒ ♭B
醉吟商小品	雙調	小工	上	正調	同右	上音 ≒ ♭B
揚州慢	中呂宮	小工	上	正調	同右	上音 ≒ ♭B
長亭怨慢	中呂宮	小工	上	正調	同右	上音 ≒ ♭B
杏花天影	中呂調	尺調	尺	正調	尺工六五乙伬仜	上音 ≒ #G
角招	黃鐘徵	尺調	尺	緊五	尺工六五仕伬仜	上音 ≒ #G
徵招	黃鐘角	黃鐘角	尺	緊五	同右	上音 ≒ #G

《淒涼犯》，曾經請國工田正德以啞觱栗角吹奏。由此可見，用這種民間常用的七聲音階去演繹白石的音樂，說不定也許接近白石道人最初的意思。經過嘗試，我們都覺得頗為諧協，於是便都用在古先生所選的十首曲上。

我們用了絲絃的古琴伴奏，由於音高和音量都比一般洞簫為低，為此我們用了較低音，音量也較小的低音琴簫以作配合。這樣一來，唱者唱得較為輕鬆，樂器與人聲都覺融合而自然。

白石道人自度曲的音樂，的確是不同凡響。其平順熨貼處，柔情千縷，忽又可以拔高而起，如飛雲來去。這次各曲都用擬宋音來唱，詞句聲調變化較多，四聲陰陽所生的斷連起伏，正可與旋律的變化互相呼應；加上板與鼓的適時插進，使句逗的感覺更覺立體。是以一路練習下來，各人於白石道人的自度曲，都深感愜意。這一次的探索，對我們來說，實是一次收穫豐盛的音樂之旅。

「姜白石自度曲十首」的伴奏音樂　蘇思棣

八年前，曾與幾位喜愛中國傳統音樂的人，探討演繹南宋姜白石的自度曲。當時我曾負責琴樂伴奏，後來改奏琴簫。八年後，舊夢重溫，再作探討。我有上回的經驗，便依舊吹奏琴簫。

傳統的六勻孔簫，與勻孔笛一樣，有等距的指孔；其吹奏出來的七聲音階，正是民間常用的七聲音階。這種音階的半音較其他律制的半音為寬，其來源或許便與勻孔簫笛有關。同樣用這種音階的，還有琵琶、觱栗（也叫頭管）等民間常用的樂器。明代產生的崑曲所用音階，也是這種七聲音階。

白石道人喜歡吹洞簫，當年過垂虹，小紅低唱他的新詞，他便以洞簫伴奏；甲寅春遇善歌的商卿，也曾以簫伴相和商卿唱他的自度曲；辛亥夏在金陵遇見懂得用琵琶彈奏《醉吟商胡渭州》的樂工時，白石道人向他請教了琵琶的品絃法，並以之創作了《醉吟商小品》；他的

別，每一曲的情緒都需要唱者用心體會。雖然唱腔經整理後已有了大致的框架，但曲中長短輕重、散唱急停，乃至特殊的聲音處理，都可以在摸索中嘗試，這是藝術的彈性，留給「作者」的創作空間。

好比《揚州慢》裏「冷月無聲」的「月」，要停得俐落，停後稍留點空白，再慢慢用低緩的聲音唱「無聲」；又如「波心蕩」裏的「蕩」，無意中唱過如「波浪起伏」的延長變化，讓人有「蕩」的感覺。唯是不是每次都能處理好，要自然而然，若刻意造就便落下乘，出來的效果相差甚遠。

最重要的還是需要唱出「曲情」，唱腔技巧的處理是可此或彼的。若唱者能有飽滿的內在情感支撐，就算簡單的唱腔，能凝起來的氛圍卻絲毫不弱。記得試唱《揚州慢》，偶有一二次唱得自己鼻頭酸，然而這種經歷可遇不可求，當知唱好曲子，殊非易事。

放過。

有同自也有異。拍曲過程中，古先生特別提醒，須小心不讓每一字的頭、腹、尾轉換過度拖沓。不同於崑曲常是一字多腔，白石詞譜唱腔基本為一字一音，一音雖也可長唱，但基本上與崑曲每字多有延宕有別，所以每一字中音素過渡不可過分雕琢，以免聽者迷失在「聲」中，而無「字」感，更會使曲中「字字雷同」的感覺大增。

唱字、腔與唱詞曲

除了須防止「字字雷同」，還要小心不要唱得「曲曲雷同」。不少初聽擬宋詞的人，會覺得每一曲聽來分別不大，這除了白石詞曲文內容、音樂風格相近的客觀原因之外，也是我們還沒能完全唱出該詞名理意趣之故。

崑曲也好，宋詞也好，唱者當提防眼中只有字，只有腔，而沒有「詞曲」。白石詞雖然都是「清空」風格，懷遠、孤寂、哀傷是詞中主旋律，但兒女私情與家國感慨還是有氣質上的分

過程中，古先生與我常討論某字閩語怎樣讀，時而修訂所擬宋音，既希望唱時體現出宋音的特點，但同時兼顧美聽且適於演唱。

或許有人會疑問，這樣揣摩字音肯定與宋音有距離。然而我們為自己下的定位很清晰，擬唱宋詞並非重現宋詞之當初，因而並不刻意為詞中每字尋根探源。帶着閩南語味道的擬宋音，有很多字的讀法與現今常用字音距離較遠，字中音素的轉換較複雜，變化明顯，感覺特別古樸，字音本身便具音樂流動的美感。

唱宋詞與唱崑曲

宋詞與崑曲同是曲牌音樂，同樣是演唱漢字的音樂，許多崑曲裏的講究，在宋詞演唱中也同樣適用。出字要「重」，指的是出字一瞬，早已做好用氣、口形準備工夫，用稍重的勁頭，使字頭清楚；過腔要「圓」，不讓聲音轉換處棱角四出，而追求轉換處無磊塊，雖然「聲中無字」，但「合聲即字」，更有一種溫潤閒靜之感；當然，還要把韻尾收好、收清楚，方是一字之終結。唱每一字，皆有頭、腹、尾，聲音的每一分寸都不容輕易

宋詞演唱的體會

陳春苗

在親身接觸宋詞演唱之前，對其僅有的認識來自張麗真老師之前所唱的白石詞。還記得當初幾位老師錄製唱片時，我在現場聆聽，印象裏是幽婉的。後來幾位老師有重錄宋詞的打算，並希望在新的製作中增加幾首新詞，也希望添加男聲的演唱。因此有了這個參與的機會。

我樂於嘗試，但無有基礎，便需要請古兆申先生先幫我拍唱。那陣子拍唱宋詞，似乎又回到跟古先生學崑曲的時候，頗相似，又有些不一樣。

擬宋音與閩南語

首先是字音，不用普通話，不是崑曲所用的中州韻，古先生擬定的宋音裏倒是帶有濃厚的閩南語味道。閩南語是宋遺音，也是我的母語，唱着似曾相識的字音，倍感親近。在拍唱

今受命按古先生訂譜擬唱白石道人歌曲，謹以多年研習曲唱所得，索字音於口法，展樂音於行腔，與樂友琴簫板鼓相和，以今人想像，追前人意韻，雖或僅及皮貌，亦足樂矣！

考。依字行腔的崑曲歌唱，建構於出字收音的口法，被採於氣息樂音的佈置。無論發聲共鳴的位置，行腔氣息的運用，都與文詞有直接的關係。較之於民歌、美聲的唱法，崑曲唱法無疑是演繹宋詞的最佳依據。詞唱不同曲唱，沒有綿長延宕的旋律，基本上都是一字一音；要在一個單音中，把字聲立體地呈現出來，切音法也就是不二之法，此亦沈寵綏所言「切法即是唱法」。至於曲家所論出字之法，是達至「字清」之要訣所在；至於收聲歸韻之法，則能使字字交代完整而無黏滯。氣息之虛實輕重，取於詠唱時之存氣、取氣、偷氣、換氣各法；至如文氣之呈現，則倚託於字聲之延宕收束。

白石道人詞，用字造句，千錘百鍊，風格清峻瘦逸，遒勁處無贅脂，婉約處有骨節。要在簡單的樂曲音節上，鋪展幽遠綿長的意韻，就必須逐字推敲，從勾勒字形開始，再衍至詞逗句韻，以臻詞情融於聲情的境界。以擬宋音詠唱宋詞，無疑最能體現文詞聲韻之美。是次錄音所用語音，俱依古兆申先生所研究的擬宋音，包括閉口音、入聲字等。如《暗香》中的閉口字「今」、「漸」，收音如遊筆收攏；入聲字「月」、「笛」、「玉」、「不」、「摘」、「卻」、「筆」、「得」、「竹」、「入」、「席」、「國」、「寂」、「雪」、「積」、「泣」、「萼」、「憶」、「壓」、「碧」等，則頓挫鮮明；這都是擬宋音詠唱所能呈現的聲樂效果，使歌唱語言的線條，一如毛筆下的各種筆法，豐富而鮮活。

我唱白石詞

張麗真

文人藝術，包括書、畫、琴、歌，都有追求線條內涵的共性。筆墨下的線條，以輕重、徐疾、頓挫、虛實，勾勒成字，織絡成篇。歌唱的樂音，以吐字、行腔、氣息、節奏，繪畫文詞，建構樂章。

宋末張炎《謳歌旨要》對於詞唱之法，如吐字行腔，有謂「腔平字側莫參商，先須道字後還腔」；字少聲多難過去，助以餘音始繞梁」；對於用氣，則有「忙中取氣急不亂，停聲待拍慢不斷；好處大取氣留連，拗出少入氣轉換」。崑曲大家俞粟廬在《長生殿·哭像》曲折跋後說：「此唐宋人論樂緒餘。元人及明季魏良輔、梁伯龍輩，洋洋數千言皆本於此。本朝乾嘉中，吳中葉懷庭先生得宋人歌詞法，亦本於此。」指出崑曲演唱之法，本於詞唱。明清曲家承接宋詞各種唱論，確立具體透徹度曲之道。明代曲家沈寵綏《度曲須知》中，有《出字總訣》、《收音總訣》；清代曲家徐大椿《樂府傳聲》中，則有《出聲口訣》、《五音》、《四呼》、《歸韻》、《收聲》、《頓挫》、《輕重》、《徐疾》等目；雖專為度曲所依，亦足堪作追索詞唱的參

一

——

分
享
篇

白石作品的風氣長期盛行，足見姜白石詞在文學發展史上的重要意義。

姜夔精通音律，能自製曲。他的詞作不拘守平仄，重視字聲和樂律的協調及情感的表達，能做到音韻和諧，別具音律美。白石道人歌曲中今存十七首自注工尺旁譜的詞作，這是流傳下來唯一的宋代詞樂文獻，在中國音樂史上有重大價值。

姜夔簡介

姜夔（公元一一五五——一二二一年），字堯章，號白石道人。南宋文學家、音樂家、書法家。

鄱陽人，少孤貧，志於功名，屢試不第。終生不仕，四處流寓，曾客淮楚、湖南間，後移居湖州，終卒於杭州。多才多藝，在詩、文、詞、書法、音樂等方面都有造詣。現存著述有《白石道人詩集》、《白石詩說》、《白石道人歌曲》等。

姜夔是南宋有影響力的詞人之一，與周邦彥並稱「周姜」。傳世詞作共八十多首，在婉約和豪放之外另樹一幟，得「清空」的評語。在內容上，雖亦有感慨時事之作，但較多是山水紀遊、歌詠愛情和詠物之作。其中詠物詞特別受文人注視，如《暗香》、《疏影》兩首，備受張炎《詞源》推重，認為「不惟清空，又且騷雅」。白石詞藝術成就獨特，其影響下及六、七百年，清代浙西詞派肯定其創作手法，常州詞派則着眼於作品寄託的感情，各自解讀和仿效姜

然不免投入演繹者的體悟和情感色彩，所以說，它不是姜白石詞樂原樣的復現。讀者不妨視「重構」為詞唱音樂接受者的反思成果。因此，藝術處理上與別不同，諸如節奏自由的吟詠風格，明顯的句逗、氣息停頓和韻腳點板。上下片之間停聲待拍，段落起伏有致。歌者用「擬宋」字音和崑曲的腔口。整體音色溫暖自然，錄音的空間感，像要引人進入悠遠的過去似的。以上特點的確與其他演繹不同。儘管洛地老師很含蓄地暗示，白石詞的譯譜問題至今未解決，但對我們大膽實驗的做法，十分鼓勵支持，感謝。

清人劉熙載《詞概》說：「姜白石幽韻冷香，令人挹之無盡」又說白石是老仙，近似「藐姑冰雪」。我們的團隊，有琴人、曲家、書畫人，憑他們傳統文藝修養的底蘊，十多年反覆琢磨，追擬古人風韻，彷彿已成了姜白石的知音。一路也真景致清幽，如入仙境，樂也無窮。久而久之，竟自圓其說，信以為不至於疏離流蕩，不着邊際，反而有踏實地更向母體親近了一步的感覺。無論如何，這場實驗，展示了向民族詩魂呼喚的誠意。

本書的發表，目的在分享心得，希望能引出更多話題，並虛心接受批評。推介本書出版的知音是陳萬雄博士，贊助這項研究計劃的，先是香港浸會大學蔡德允女士教學及研究基金，後有美國密歇根大學孔子學院。對於他們的慷慨支持，我們深致謝意。

一
〇

讀文學而好古的人，對姜白石詞歌唱的一面，似乎抱着更多的好奇與遐想，可惜研究信息多在文學方面，目前能找到的姜白石詞音樂演繹，未能令人滿足。或者說，坊間好些現代化處理，未能與我們對宋詞僅有的認識和想像呼應。例如說，沒有入聲字、韻腳無處着落的普通話讀音，西洋美聲唱法，不合詞體結構原理的句逗停頓與節拍安排，加上鋼琴伴奏、大型民樂交響之類的編配等，如此總總，與我們想像中的宋代音樂有距離，也接應不上來自閱讀的姜白石詞印象——清空風格、低唱吹簫、暗香疏影的意韻。至少，在審美直覺上未能說服我們。這正是探索團隊一再出發尋訪的理由。

記不得多少年以前，幾位愛好崑曲的朋友，在古兆申的鼓動之下，嘗試用「擬宋音」和崑曲口法去演繹姜白石歌曲，並以古琴洞簫伴奏。開始時以遊玩心態嘗試，其後嚴肅地進行實驗。二〇〇四年香港浸會大學大學中文系發表了第一次錄音《姜白石詞擬唱》。至二〇一二年，新組成的團隊又在香港浸會大學辦了一場姜白石詞的演唱會，得到詞學專家張宏生教授、音樂學界余少華教授和楊元錚教授、崑曲專家古兆申博士，一共主持了四場學術演講。同年，演唱團隊應邀訪問美國密歇根大學，演出歸來做了二度錄音。現在我們集合專家演講稿、樂人心得與歌曲音響，編成這本小冊。

由「擬唱」到「重構」過程，是據一定學理基礎出發的實驗，也含有一定程度的再創作，自

漢語的先天規律有密不可分的關係。

二十世紀中國的詩和樂，都脫離母體往外狂奔。新詩告別古典格律，出現佶屈聲牙、拗口難讀的詩句，再不能成歌。音樂也與傳統決裂，尤以西化知識界為首，以傳統音樂為簡陋落後，改服洋裝，自此音樂文化環境急劇改變。時至今日，除了一直在極速消弭的戲曲音樂與民間音樂，或尚懸一息之外，二十世紀建構的「中樂」、「華樂」、「民族音樂」主流，莫不是西體中用的舶來腔調、與母語不協諧的時代新聲。這可是時代的選擇，懂音樂的、不懂音樂的，都難以分解。幾代人在中西混雜的音聲中成長，一般受着學校教育的主流和日常媒介的潮流影響，對於甚麼是民族特色的詩歌音樂，總是萬般隔膜模糊。

有人說，一代有一代的詩歌，一代有一代的音樂。音樂抽象虛無，流動不定，隨時而流走。古典音樂失傳，從來如是，不只在二十世紀。例如，韻文發展到宋代出現歷史的新高峰，詞體形成了，詞調無不能歌，「凡井水飲處，即能歌柳詞」。宋詞的詩文和樂歌，原來就是同行並步的藝術式樣。不論是詞的文體抑或詞的音樂，到了南宋更趨成熟和規範，還出現了詞的音樂記譜。可惜它的發展因元人的入主而停滯。自此，依格填詞代有作者，詞唱的音樂卻失傳了。姜白石遺下附有記譜的十七首詞，是現存詞樂唯一的唱譜，成為留給後人推敲、破譯、爭議和憑吊的文化遺產。

編者語

「所謂伊人，在水一方。溯洄從之，道阻且長。」

這是再次逆流洄溯的探索旅程。嘗試透過姜白石歌曲的訪尋，呼喚遙遠的詩心樂魂。

詩大序説：「在心為志，發言為詩。情動於中而形於言，言之不足故嗟嘆之，嗟嘆之不故永歌之，永歌之不足，不知手之、舞之、足之、蹈之也。」作為文藝之中最純粹的兩種類型，不論從發生源頭或藝術形式説，詩和歌關係密切如同雙生姐妹，同是直接從民族靈魂流出的心聲。

華夏民族以詩立國。自詩經、楚辭、樂府、唐詩、宋詞至元曲，古典詩歌體式演變一脈相承。幾千年間，不論哪一種詩體，都能化文詞為樂歌；意謂中國人不論住甚麼地域、説甚麼方言，從來可以自然地運用母語詠誦、吟唱詩句。所謂凡詩皆可歌、依字行腔的現象，與

詞，他們所做的，只是在二十一世紀的語境下，借助想像，盡可能貼近宋人的演唱方式。對於聽者而言，他們以極為傳統的方式實現了這一目標。換言之，他們富於創造性地闡釋古典音樂，又忠實於原作的藝術特點與內涵。美國密歇根大學孔子學院參與及支持這一項目，與有榮焉。我獲邀作序，也深感榮幸。

序二

林萃青

白石詞是南宋文學史與音樂史上的傑作，此次由古兆申博士與劉楚華教授牽頭，諸多學者與表演者共襄盛舉，重現了白石道人歌曲。如今，根據《宋韻遺珍——白石道人歌曲重構》一書及演出錄音製作的光碟即將出版，意義重大，我要向參與此項目的學者與表演者表示祝賀。在姜夔生活的時代，宋詞本是在音樂伴奏下演唱的。十七世紀以降的中國人，僅僅視之為文學上的佳構。自從上個世紀五十年代，不少音樂家紛紛致力於再現宋詞演唱。

然而重構白石詞困難重重，迄今為止的擬唱大多不盡如人意。原因之一是白石詞曲譜太過簡略，節拍又難以辨識。其二，由於古今語音演變，無論是今日的普通話，還是各地方言都難以還原原作的字音。其三，對於白石詞演唱的細節，今人不得而知，而用今日的演唱方法，尤其是飽滿、洪亮的西洋唱法演繹白石詞，實在有時代錯亂的不和諧之感。有鑒於此，此次擬唱採用崑曲唱法，並借用擬宋音。由於表演者均是崑曲曲家與古琴家，就聆聽錄音的效果而言，可以說是技藝精湛，富於表現力。不過他們有言在先，重構白石詞並非復原白石

板，魚魯亥豕；故尚未可一定。而付諸管弦、謳於歌喉者益鮮。香江古兆申、張麗真、蘇思棣、劉楚華、陳春苗、鍾兆燊諸先生，中華文化傳承有心人也。甲申之年曾以姜白石詞擬唱布世，其唱奏八詞，頗具雅正意趣。自二〇〇四年來猶孜孜不倦，細心琢磨。今溫故知新，重作梳理，又增添二詞，再獻擬唱，是更上層樓之舉也。洛地深賞而賀之，乃撰序如上。

序一

洛地

白石道人姜夔，南宋詞人。其詞作以清空而自成一家。其詞唱具旁譜而領詞樂首席。

詞，多有極許唐五代者，按其體式，實成於北宋而大盛於南宋。詞之樂唱，素眾說紛然。審視二十八調中高宮之律位，最足試竽。凡仁宗樂髓、夢溪、玉田等，及清凌廷堪乃至今人，無不置高宮調頭於雅律大呂，可謂自暴紙兵。惟王晦叔灼、姜白石夔奏高宮調頭於俗律姑洗（雅律太簇），真樂士此二人也。最者，白石以其通貫雅俗之越九歌律呂譜、十七律詞管色指法旁譜，獨步詞壇。其角招一曲，盡破舉世閏角之謬。蒙元滅宋，詞學中斷。白石歌曲，乃成詞曲之絕唱。

夢溪筆談燕樂，其律呂音聲參差。人稱清真知樂，其用調羽宮不分。

白石歌曲，明清詞界虛譽如蜂，深究者一個也無。二十世紀始有夏承燾、楊蔭瀏、陰法魯、丘瓊蓀等有數大家研剖翻譯，功莫大焉。然宋譜符號與今大異，簡甚且不一；又轉輾刻

四、聲樂重構篇

目錄

本書承蒙香港浸會大學蔡德允教研基金及美國密歇根大學孔子學院贊助出版。

Confucius Institute at the University of Michigan

密歇根大学孔子学院

宋韻遺珍——白石道人歌曲重構

主　　編：劉楚華

英語翻譯：崔文東　林順夫

責任編輯：蔡祝音　續瑜

封面設計：楊愛文

出　　版：商務印書館（香港）有限公司
　　　　　香港筲箕灣耀興道 3 號東匯廣場 8 樓
　　　　　http://www.commercialpress.com.hk

發　　行：香港聯合書刊物流有限公司
　　　　　香港新界荃灣德士古道 220-248 號荃灣工業中心 16 樓

印　　刷：美雅印刷製本有限公司
　　　　　九龍觀塘榮業街 6 號海濱工業大廈 4 樓 A 室

版　　次：2022 年 6 月第 1 版第 3 次印刷
　　　　　© 2016 商務印書館（香港）有限公司
　　　　　ISBN 978 962 07 5654 2
　　　　　Printed in Hong Kong

宋韻遺珍

白石道人歌曲重構

劉楚華 主編

商務印書館